MEKONG

The Last River
Kenji Aoyagi

Cadence Books

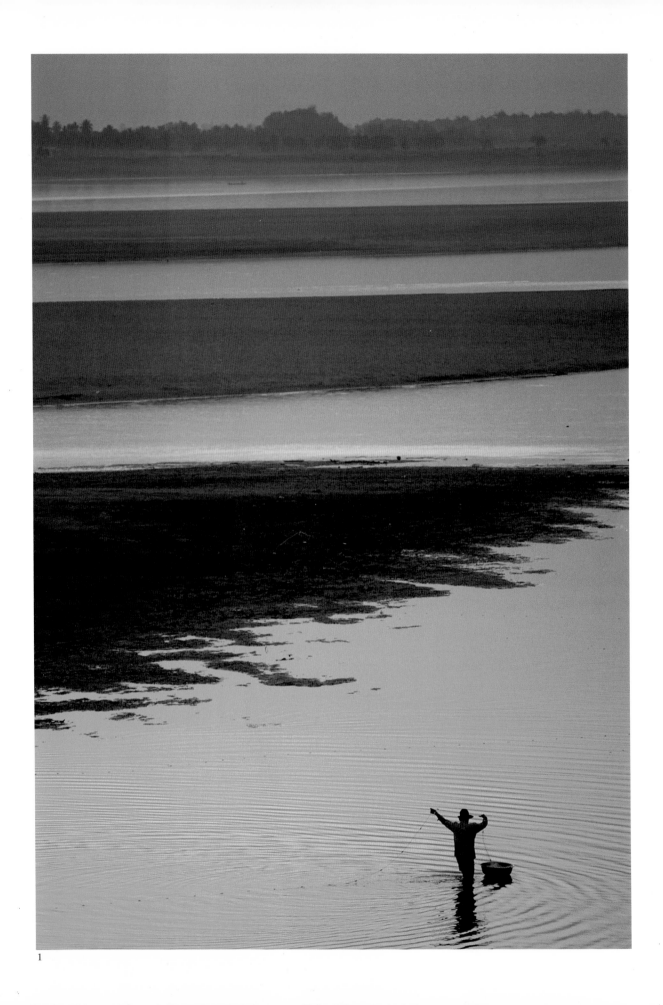

1

Executive Editor/Seiji Horibuchi
Translator/Yuji Oniki
Book Design/Shinji Horibuchi
Publisher/Keizo Inoue

© 1995 by Kenji Aoyagi

Map created by Hiroyuki Kimura and
Sachiko Ogiwara (TUBE)

Special thanks to Norio Isobe,
Kunihiro Takahashi, and Kyoko Seto

Printed in Japan

Simultaneously published as
MEKONG, THE LAST RIVER by NTT
Publishing Co., Ltd., Tokyo, Japan.

ISBN 1-56931-089-0

First printing, November 1995

Cadence Books
A division of
Viz Communications, Inc.
P.O. Box 77010
San Francisco, CA 94107

NOTE:The mark "◀" beside a
caption indicates that it refers to
the image one page before; the
mark "◀◀" refers to the image
two pages before.

CONTENTS

1
In Vientiane, during the February
dry season, the Mekong recedes.
At sunset, someone fishes near an
exposed sandbar. L a o s.

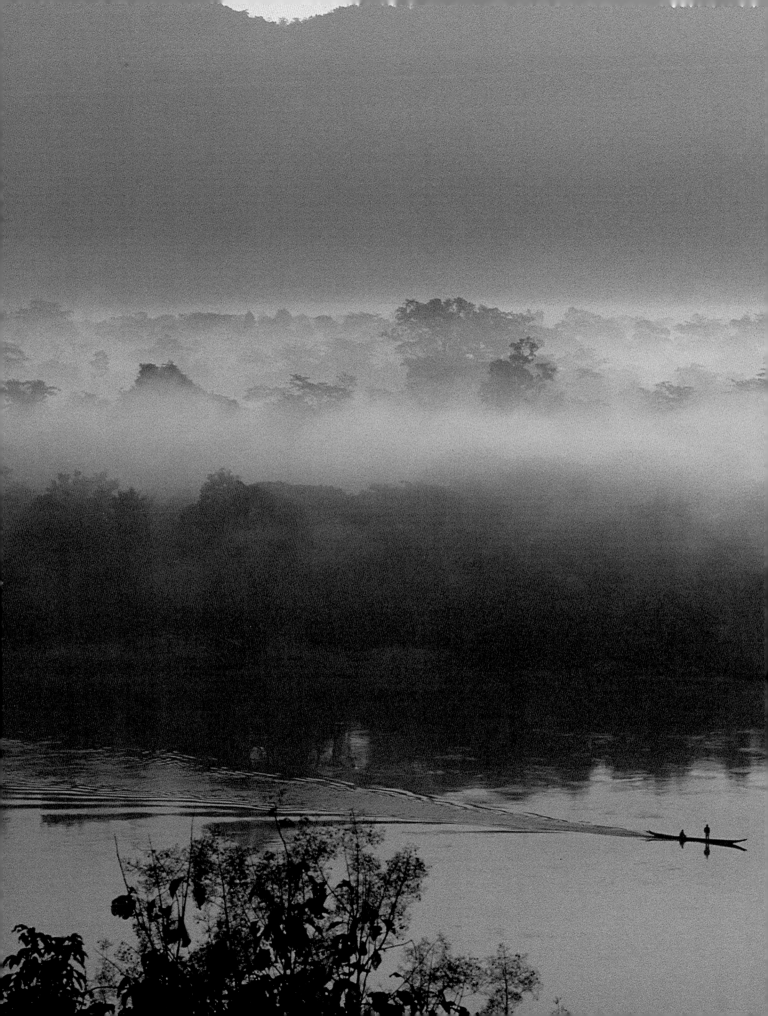

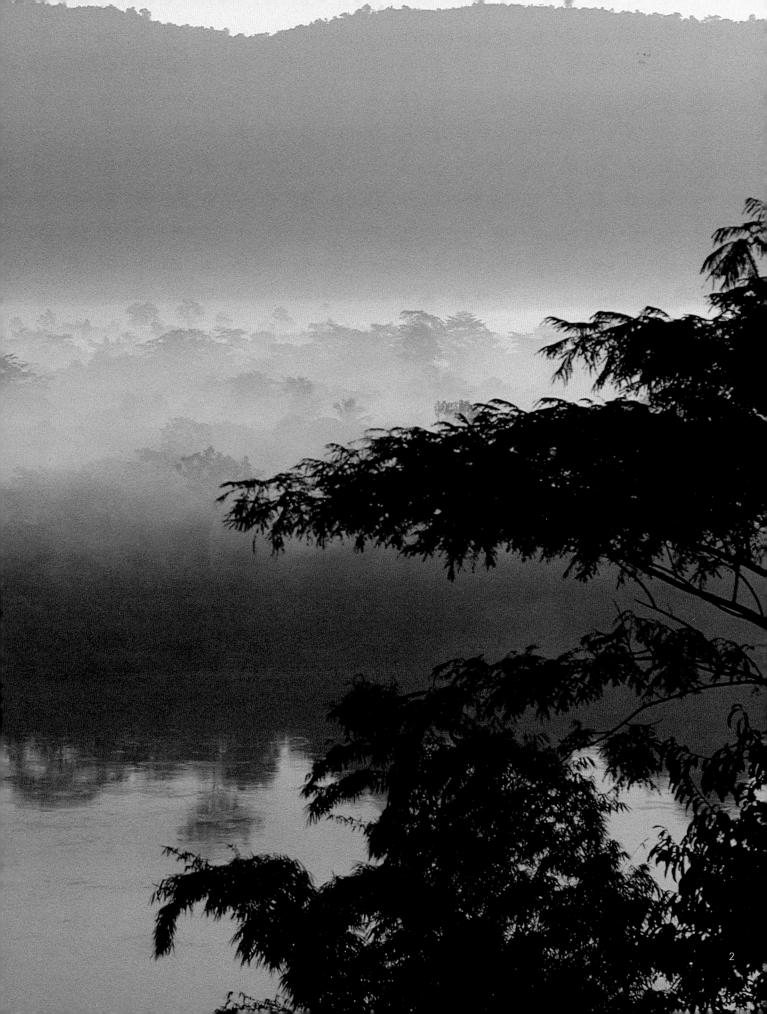

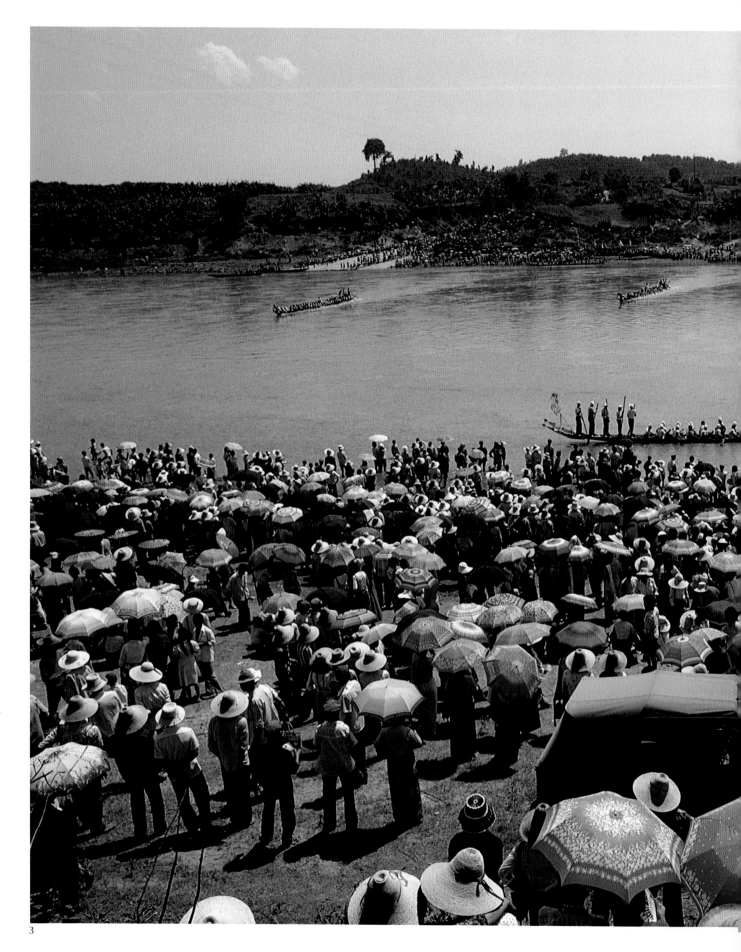

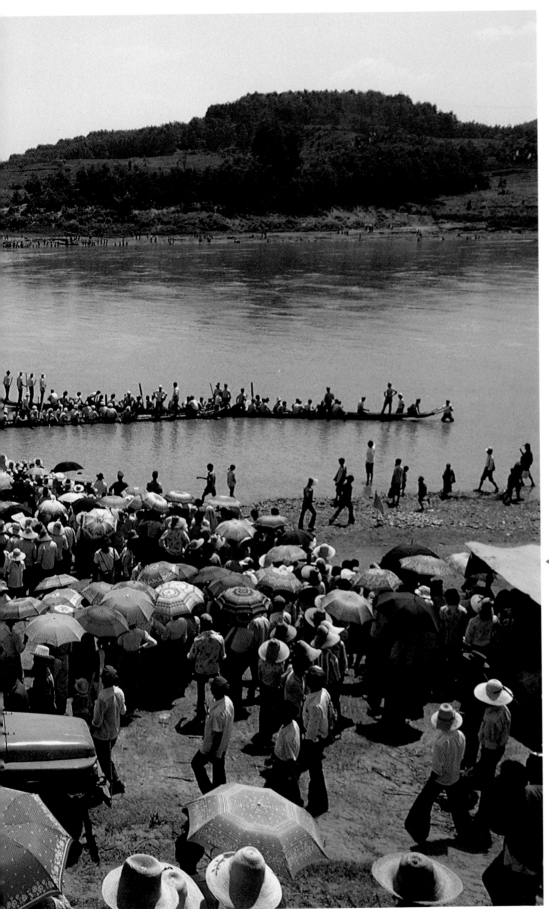

◄◄ 2
Morning in the Golden Triangle,
where the borders of Thailand
(foreground), Laos (across the
river), and Myanmar (left) meet.
Buses crowd this popular tourist
attraction during the day.

3
The Dai people celebrate the
New Year in mid-April (before
the rainy season) with a Water
Splashing Festival and dragon-
boat races. Y u n n a n, C h i n a.

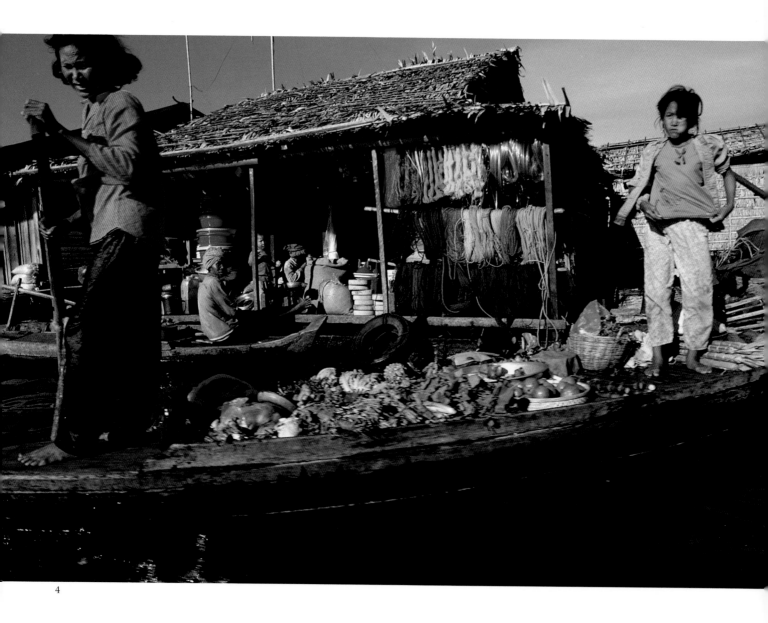

4

4

A village of houseboats in Tonle Sap, Cambodia. Barber shops and stores selling everything from groceries to electrical supplies line both sides of the main waterway.

5

Young people pose in front of the statue of Ho Chi Minh in Ho Chi Minh City. Due to its location at the river's mouth, this city plays a prominent role in the Mekong's overall development. V i e t n a m.

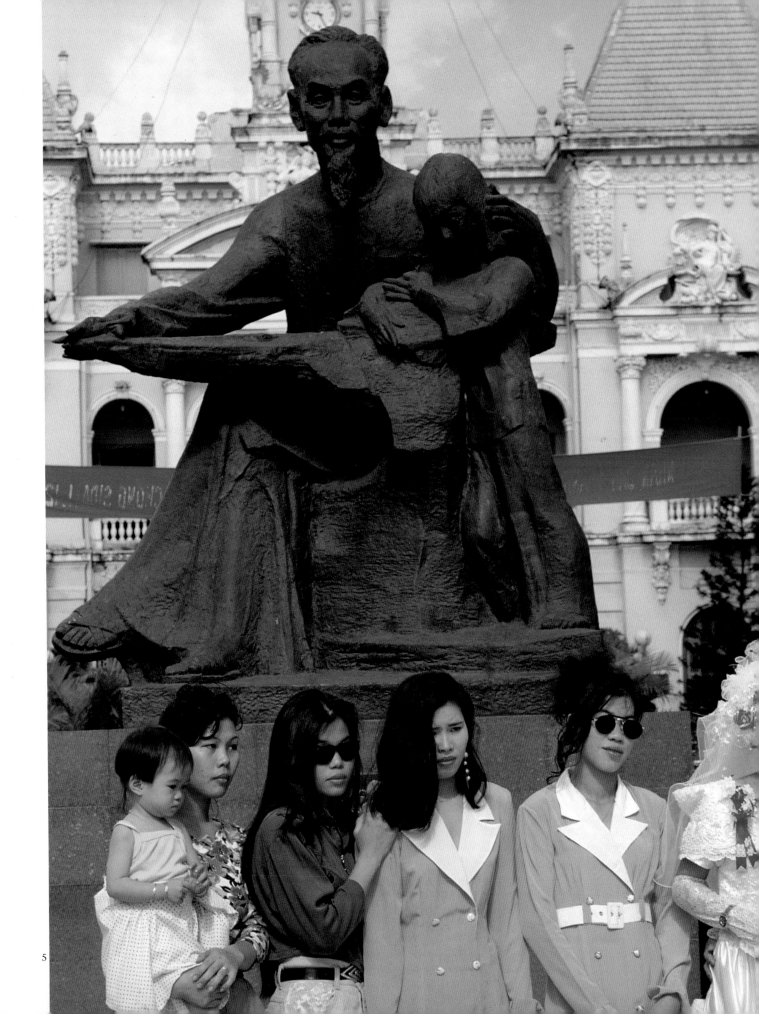

PREFACE

Where does the Mekong River begin, and where does it flow? I wondered as I opened the map nine years ago. It was my second year visiting China's Yunnan Province. I was watching the dragon boats racing in the Dai people's Water Splashing Festival, held to celebrate the New Year. This was where I first encountered the Mekong. The river can be traced back to the Tanggula Mountains of the Tibetan Highlands, located in the southern region of Qinghai Province. From there, the Mekong flows along the borders of Myanmar, Laos, and Thailand, enters Cambodia, and then descends through the south of Vietnam, spreading out at the Mekong Delta before finally emptying into the South China Sea. With a total length of 2,600 miles traversing six countries, this river is not only the longest river in Southeast Asia, but also one of the longest rivers in the world.

Despite its enormous, transnational length, there has never been any full-scale development of the Mekong. The upstream waterfalls and rapids have prevented the transportation of both people and goods. Furthermore, beginning in the late eighteenth century, territories along the river were colonized by France, England, and subsequently, Japan. From the onset of the Vietnam War, followed by the Cambodian civil war and the border conflict between China and Vietnam, the Mekong was continuously overwhelmed by political conflicts, which prevented development in the area. The title of this book of photos, *"The Last River,"* refers to the rarity, worldwide, of a river left virtually pristine.

6

In southern Yunnan, Lahu tribes-
people descend the mountain by
foot to attend a weekly market.
The trip takes three hours.

I began taking pictures of Yunnan Province in 1985. Over the next few years, I visited the province more and more frequently, because I was drawn to the traditional lifestyles of Yunnan's inhabitants. In Yunnan, I felt spiritually fulfilled. Perhaps that explains why I ended up spending half my time there one year, and a total of twenty-six months altogether. In 1986, while visiting the southern region of Yunnan, I discovered that trade took place at the border—although not as prevalently as it does today. I learned that goods such as Myanmar candy and Thai perfume were sold at markets there. I also met local inhabitants who informed me that they had traveled to Myanmar or Laos to visit their relatives. All of these encounters made me realize that borders do not necessarily confine people. There are roads continuing well beyond a nation's boundaries where one can find members of the same tribe. And in the same region, tribes growing rice crops in the lowlands beside the Mekong have customs completely different from those farming dry fields in the surrounding mountains. I was taken by the peaceful coexistence of such diverse groups. My observations led me to believe that one can characterize Asia and its various peoples in terms of changes in altitude.

I extended my investigation beyond Yunnan Province, eventually deciding that the Mekong would guide the course of my journey. At the time, however, traveling along this transnational river was impossible, because it passed through the politically conflicted area of the Indochinese peninsula.

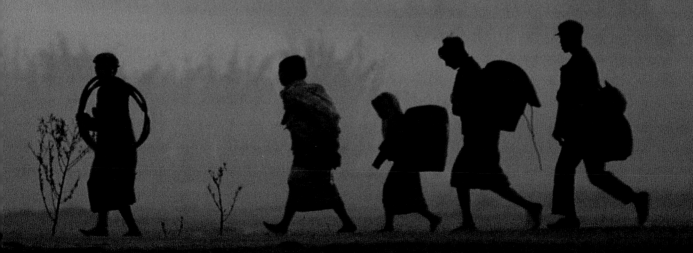

Fortunately, circumstances have improved rapidly over the past several years. With the end of the Cold War, as peace gradually comes to Asia, the various countries through which the Mekong passes have begun to participate in active exchange, opening themselves up to foreigners as well. Until recently, the Mekong was partitioned regionally, but now it has become unified. When I decided to finally begin my long-awaited journey along the full length of the Mekong, I expected the trip to be a long one. Nonetheless, I was surprised at how much time it took. Even now, an uninterrupted descent down the Mekong is impossible by ship or boat. I encountered numerous other obstacles as well. For example, no roads run alongside the Mekong, so where the water was impassable, I could only "connect-the-dots" between places. Some areas were closed off to foreigners, and some regions were still politically unstable, so at times it seemed as though the trip would not be completed. But with the help of good luck, in December of 1994, I descended from the mouth of the river into the South China Sea. Finally, I was able to grasp a complete picture of the Mekong.

In general, the tribes of the river regions have a history of moving south along the Mekong. I chose to follow the same path, beginning at an altitude of 16,000 feet and traveling down to sea level at the river's mouth. I experienced for myself how cold and harsh the environment was at the source of the Mekong, as well as how the weather warmed and how increasingly abundant goods became as I

descended. By photographing at several gradations of altitude, I could examine the differences between various cultures and peoples along the river.

In April of 1994, near the midpoint of the Mekong, the first bridge across the border between Laos and Thailand was constructed. A transnational ship now runs from Yunnan Province to Thailand and Laos. Despite the excellent preservation of the Mekong's natural state, due to this large-scale development, the river is now beginning to change rapidly. Those tribes that transcend borders defined by nations will be forced to conform to the policies of their respective countries, which will increasingly advocate exchange and commerce. As a result, new cultural and economic spheres must emerge. This land, named "Indochina" in the nineteenth century because it lies between the enormous cultures of India and China, is now beginning to form a new and distinct entity, a "Mekong cultural sphere," centered around the whole of the river. In this sense, the Mekong can be considered a symbol for the new, rapidly emerging Asia.

It is unfortunately also the case that the traditional cultures that evolved over the long history of the peoples of the Mekong will be lost as well. The scenes in this book of photos will most likely become a thing of the past. That is another reason why this book is called *"The Last River."*

Kenji Aoyagi

7

In Vientiane, the rainy season comes in July. As a storm dissipates, the evening cools, and a boat glides across the surface of the deep, wide Mekong. L a o s.

MAP OF THE MEKONG RIVER AND VICINITY

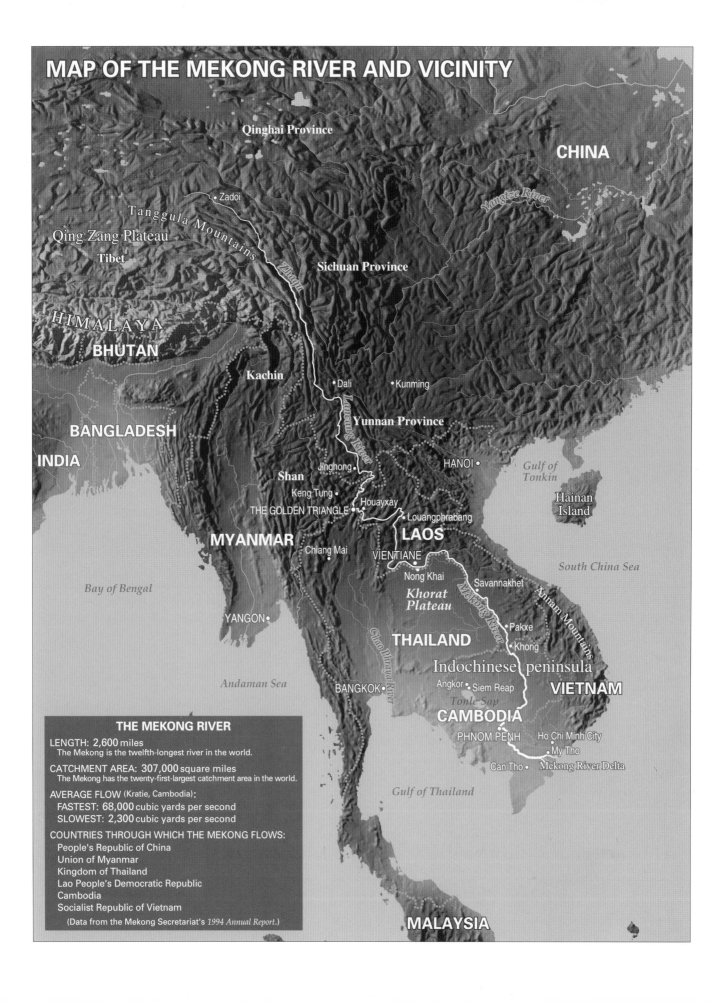

Qinghai Province

CHINA

Zadoi

Tanggula Mountains

Qing Zang Plateau

Tibet

Zhiqu

Sichuan Province

Yangtze River

HIMALAYA

BHUTAN

Kachin

Dali

Kunming

BANGLADESH

Lancang River

Yunnan Province

INDIA

HANOI

Gulf of Tonkin

Hainan Island

Jinghong

Shan

Keng Tung

THE GOLDEN TRIANGLE

Houayxay

Louangphrabang

LAOS

MYANMAR

Chiang Mai

VIENTIANE

South China Sea

Nong Khai

Savannakhet

Annam Mountains

Khorat Plateau

Mekong River

Bay of Bengal

YANGON

Pakxe

Khong

THAILAND

Chao Phraya River

Indochinese peninsula

VIETNAM

Andaman Sea

BANGKOK

Angkor Siem Reap

Tonle Sap

CAMBODIA

Ho Chi Minh City

My Tho

PHNOM PENH

Can Tho Mekong River Delta

Gulf of Thailand

THE MEKONG RIVER

LENGTH: 2,600 miles
The Mekong is the twelfth-longest river in the world.

CATCHMENT AREA: 307,000 square miles
The Mekong has the twenty-first-largest catchment area in the world.

AVERAGE FLOW (Kratie, Cambodia):
FASTEST: 68,000 cubic yards per second
SLOWEST: 2,300 cubic yards per second

COUNTRIES THROUGH WHICH THE MEKONG FLOWS:
People's Republic of China
Union of Myanmar
Kingdom of Thailand
Lao People's Democratic Republic
Cambodia
Socialist Republic of Vietnam

(Data from the Mekong Secretariat's 1994 Annual Report.)

MALAYSIA

MEKONG
The Last River
Kenji Aoyagi

Cadence Books

8 The source of the Mekong. Qinghai, China.

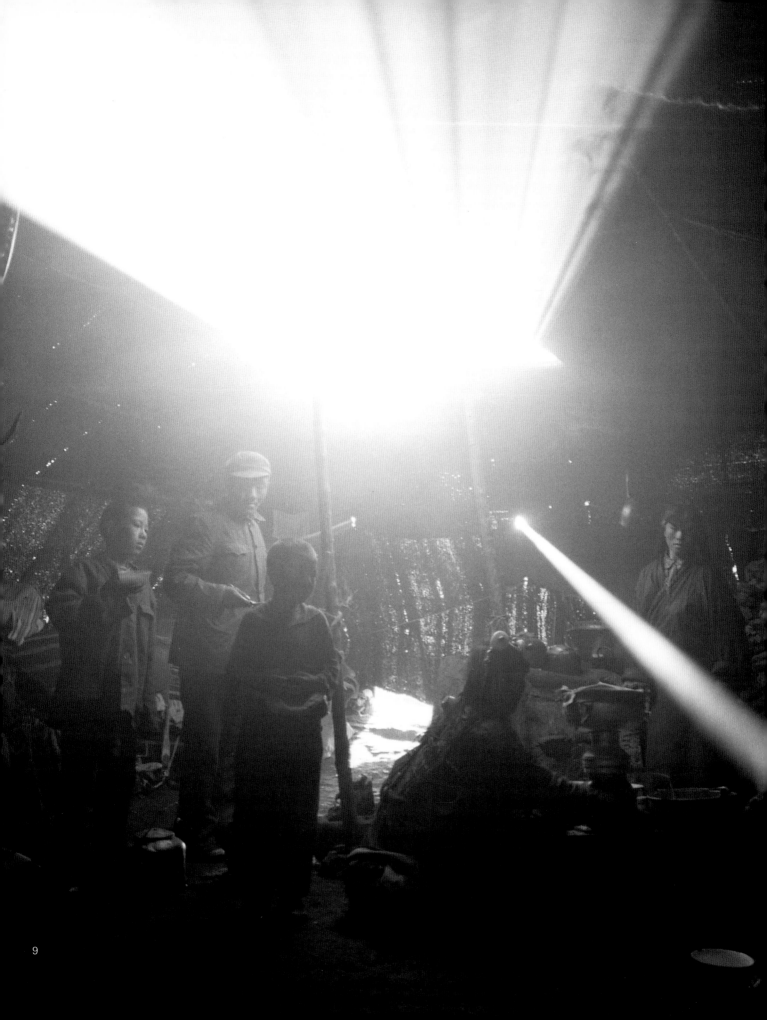

The morning was cold, and transparent as glass. This was the day we would finally reach the source of the Zhaqu, known as the headstream of the Mekong River. After having butter tea and yogurt at the herdsmen's tent, we headed upstream.

After a night's rest, my headache had somewhat subsided, but my face remained swollen, and my nose continued to bleed. At a height of 15,000 feet, these uncomfortable effects of altitude should have come as no surprise.

It had been no easy task getting this far. We had driven approximately 750 miles southwest from Xining, the capital city of Qinghai Province, finally reaching a village thirty miles away from the river's source. We had also crossed the headwaters of two large rivers, the Yangtze and the Yellow River. How many peaks between 13,000 and 16,000 feet in height had we scaled? We had also driven through grasslands and riverbeds barely functional as roads. Eventually, my guides and I switched to horses and rode over swamplands and prairies, finally stopping to set up our tents and spend the night by the herdsmen's tent near the source of the Mekong.

We climbed up the riverbed of the Zhaqu. As the stream narrowed, one of the guides said, "This is the spring," and pointed his finger at the riverbed. This was the source? Water leaked through the ground, making it look more like a puddle than a spring. In fact, the river seemed to continue further upstream.

This sight was quite different from the one I had pictured. I wasn't satisfied, and pressed the guides, "Isn't the 'real' source of a river where the first drop of water appears?" They raised their eyebrows and protested, "The 'real' source? This is the real source. When winter comes, the water upstream dries up or freezes over, and even in summer its level changes unpredictably every day. But from this spring, water flows year-round, so it is a precious source of water for both people and their livestock. That's why we call this place the source of the river."

Where the Dragon God

Descends from the Sky,

the Journey Begins

AT THE SOURCE:
THE TIBETAN HIGHLANDS
AND YUNNAN PROVINCE

9
These Tibetan herders live in Mo Yun, near the Mekong's source. In this tent home, yak manure is burned in a furnace for cooking and heat. Q i n g h a i.

We were at the foot of the cone-shaped holy mountain. According to local mythology, this spring is protected by a dragon sent by the gods of the sea.

Upon hearing their explanation, I began to understand why they called this puddle the source. When I had been imagining the source of the Mekong I didn't except many people to live nearby. Also, I was thinking in solely geographic terms. In Tibetan, "Zhaqu" means "spring-water that flows between mountains." These people chose a name for the river that reflects its role in their daily lives. As my goal was to see the source of both the Mekong and the Zhaqu, I had to respect the spring's significance to my guides as a spiritual holy ground.

When I awoke the next morning, I noticed scaly patterns on the tent. I poked at them with my fingers, and suddenly they crumbled, falling to the ground. No! I thought, as I jumped out of my tent. To my surprise, everything outside was completely white. The snow was still falling. Despite the high altitude, the day before had been clear and warm as summer, yet now, within a single night, winter was here.

In spite of the snow, the village women were quietly working hard outside, milking yaks. When I got close to them, one of them asked me, "Are you cold?" I answered, "Of course I am!" making a face as if to say that was natural because of the snow. She replied, "I'm not cold," and smiling, continued to milk. She seemed to be beaming with self-satisfaction. To her, snow in the summer was simply an ordinary fact of life.

As the cloudy weather began to clear, I came out of my tent again. I held my breath at the sudden sight of the sun shining on the holy mountain decorated in snow. I rushed to take out my camera, but by the time I looked up again, the mountain peak was hidden behind a low-hanging cloud.

It was a spiritual moment. The dragon descends upon the holy mountain at moments like this, I thought to myself. As I imagined the dragon protecting the vital spring which gives forth the water of life, I straddled my horse, and left the source of the Mekong.

18

10
By the banks of the Mekong, at
an altitude of 15,000 feet, a
Tibetan tribe raises yaks, sheep,
and horses. The frost turns the
prairie white. Q i n g h a i.

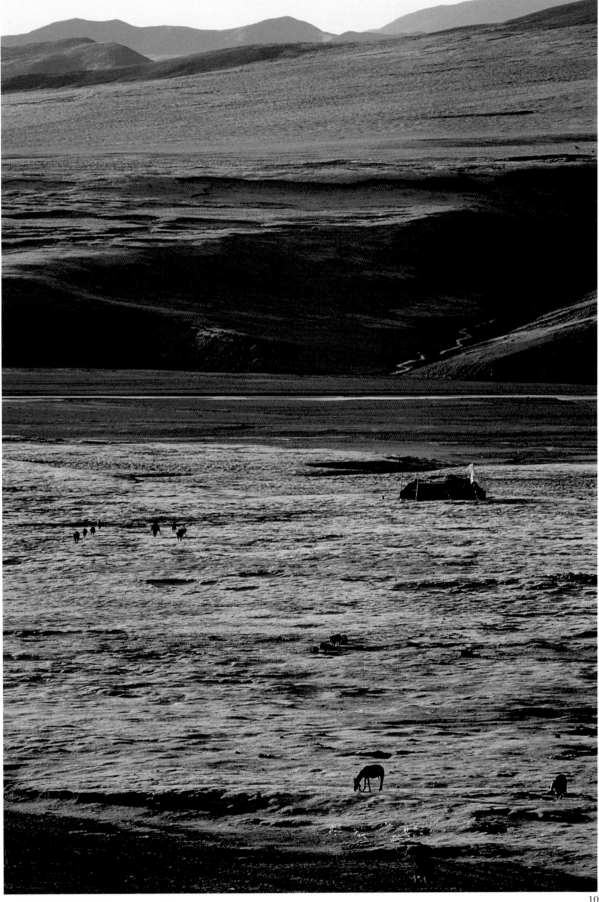

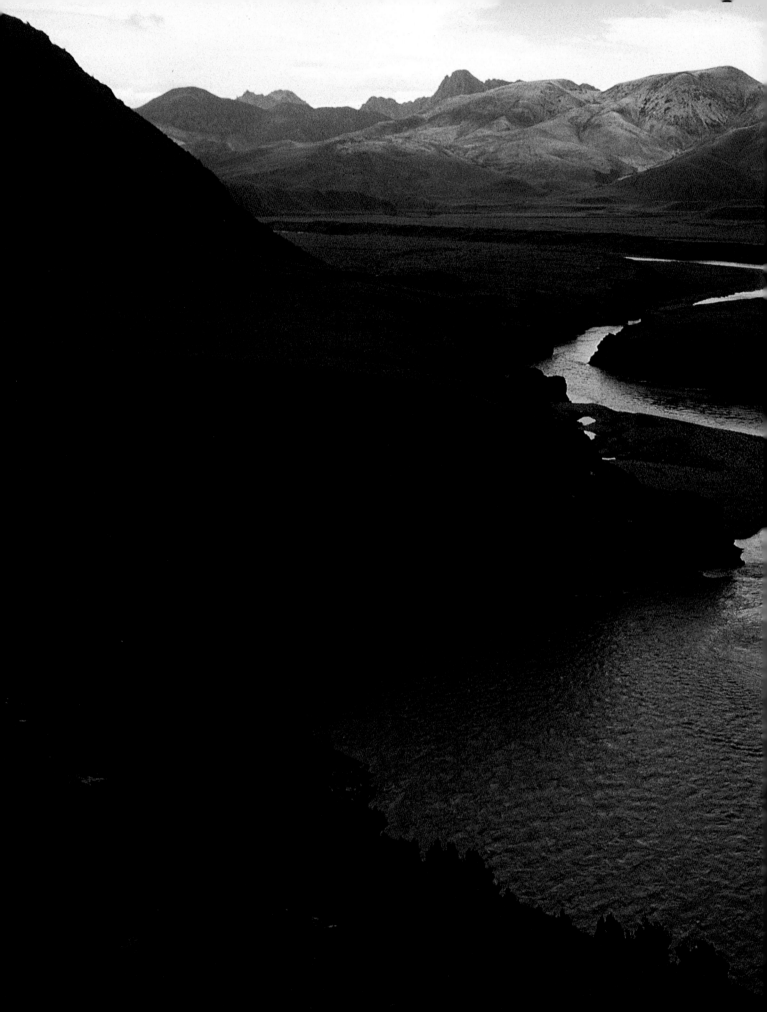

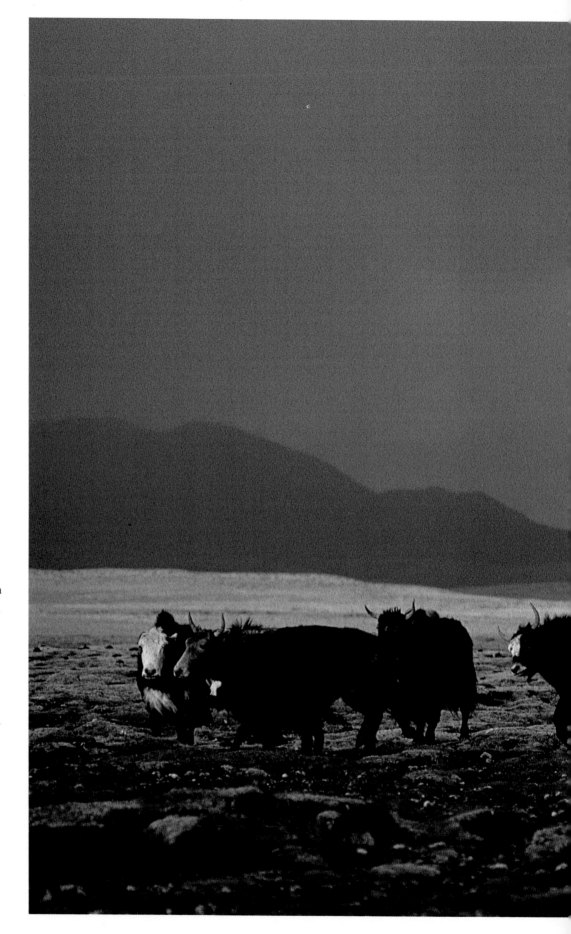

11

Although the Zhaqu is the source of the Mekong, it still turns brown after it rains. The South China Sea is 2,500 miles away. Q i n g h a i.

12

In the evening, a girl swings her sling as she chases a yak. Her tribe depends on yaks for survival. A yak's wool is used for making tents, its meat for food, its fat for food and light, and its manure for heat. Q i n g h a i.

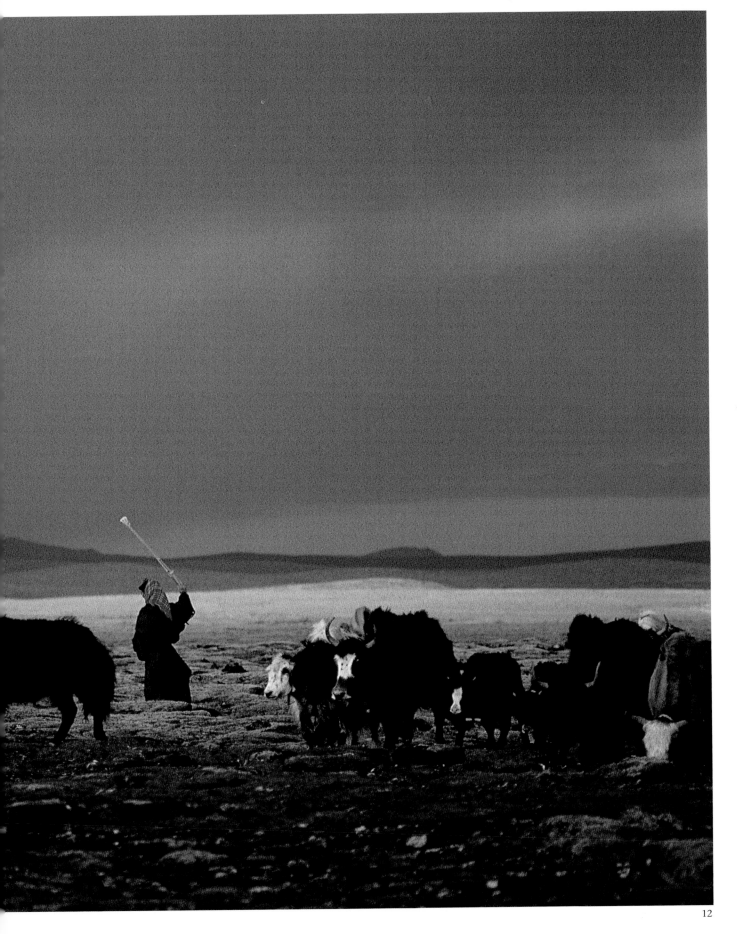

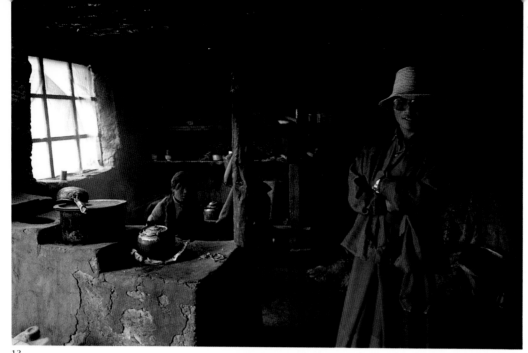

13

13

This family home is built from bricks of dried mud. The son is a novice monk at his village's Buddhist temple. Even at the source of the Mekong, young men sport sunglasses. Q i n g h a i.

14

This family's staple food is a type of dumpling kneaded with butter tea. The mother prepares a meal while boiling tea. Her daughter appears curious about the camera.

15

Before she milks the yak, the old woman has the yak's calf suck on the cow's teats to start the milk flowing. Q i n g h a i.

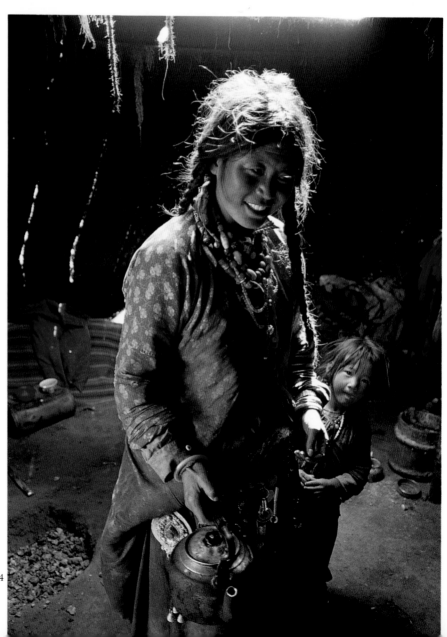

14

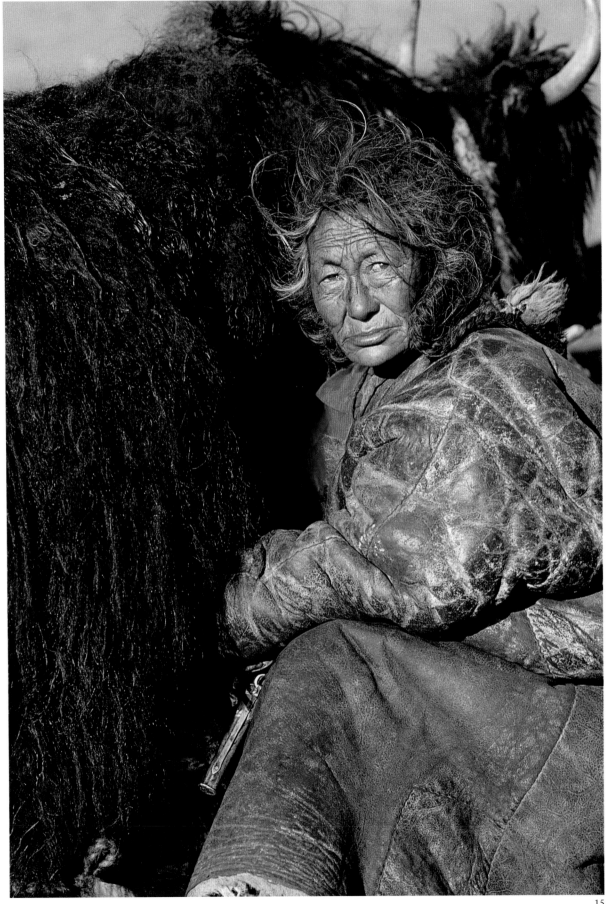

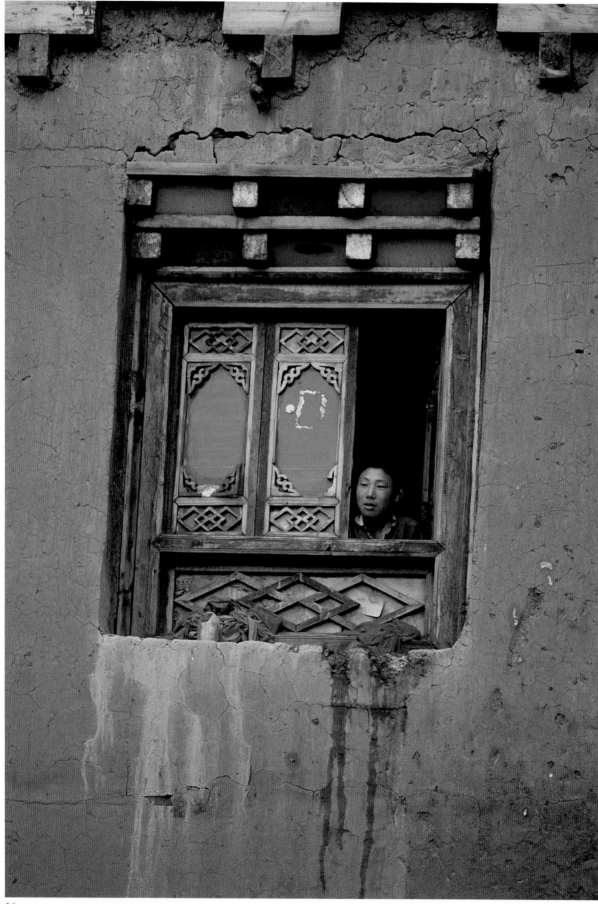

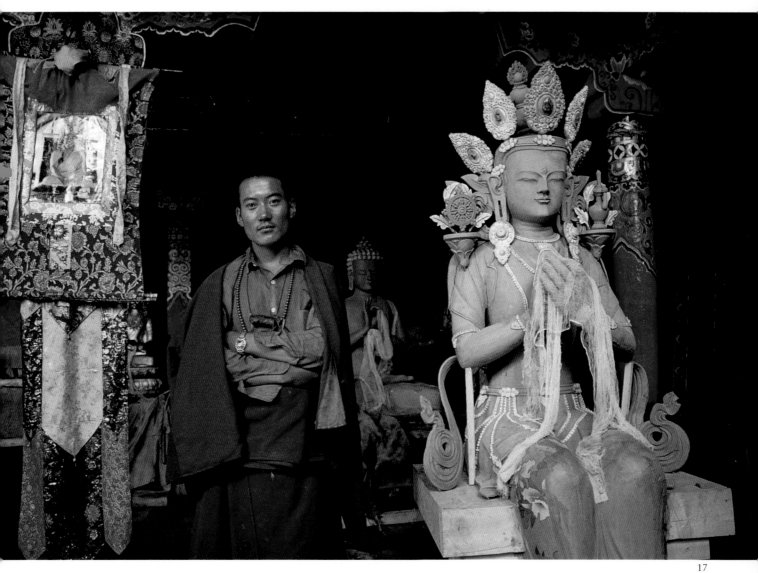

16
Zuoqing Temple lies northeast
of Zadoi, ninety miles from the
Mekong's source. I could hear
voices chanting in the hall.

17
Siri Temple is a little over a mile
upstream from Zadoi. The first
temple in this area, built in 1568,
was destroyed during the Cultural
Revolution. This priest is wearing
a broken wristwatch. Q i n g h a i.

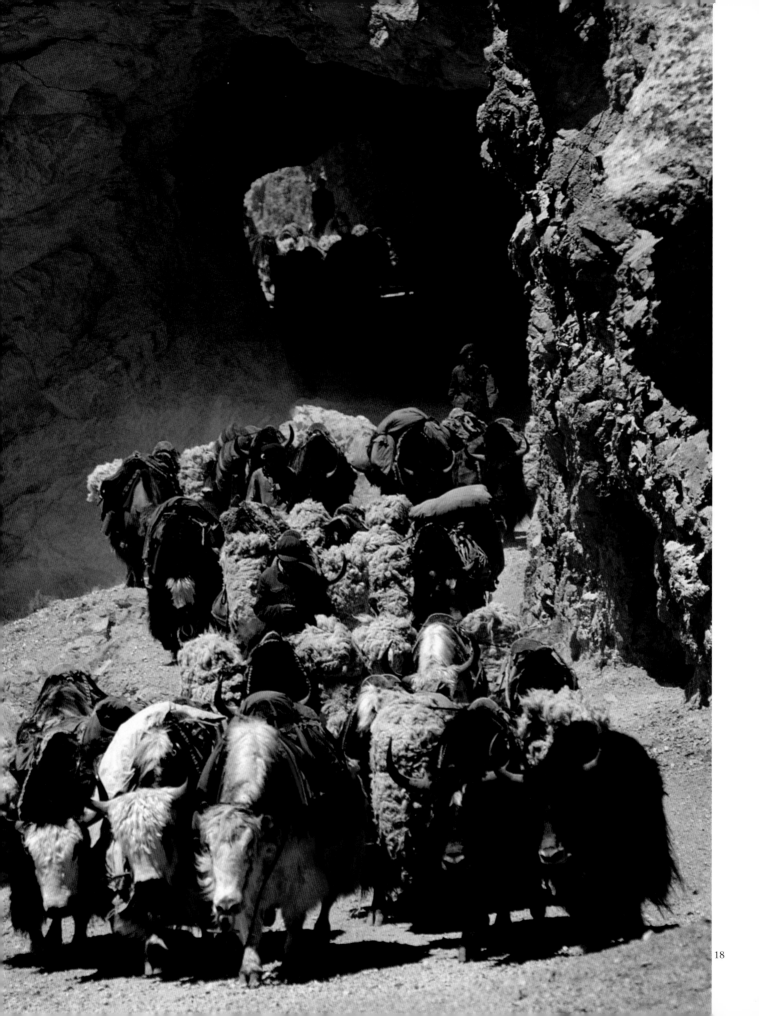

18
This caravan is traveling along the
Mekong to Zadoi to barter yaks'
wool. These people go there four
times a year to exchange wool for
food. Q i n g h a i.

19
At an altitude of 15,000 feet, it
snows even during the summer.
However, the cold weather doesn't
prevent these women from taking
care of their yaks or washing
clothes. Q i n g h a i.

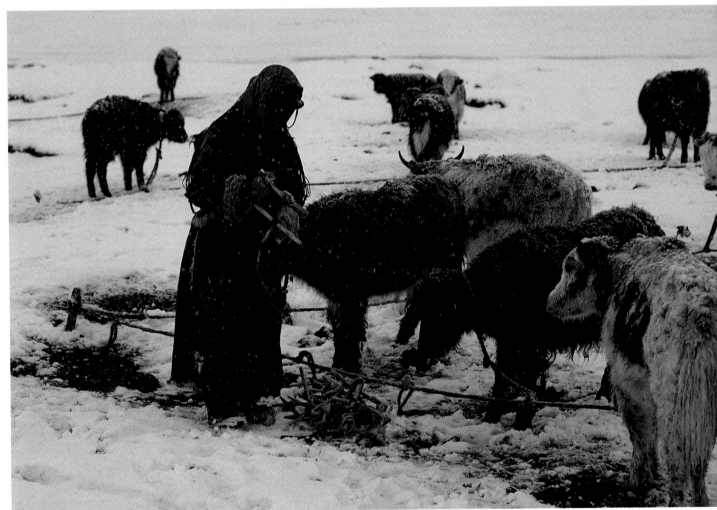

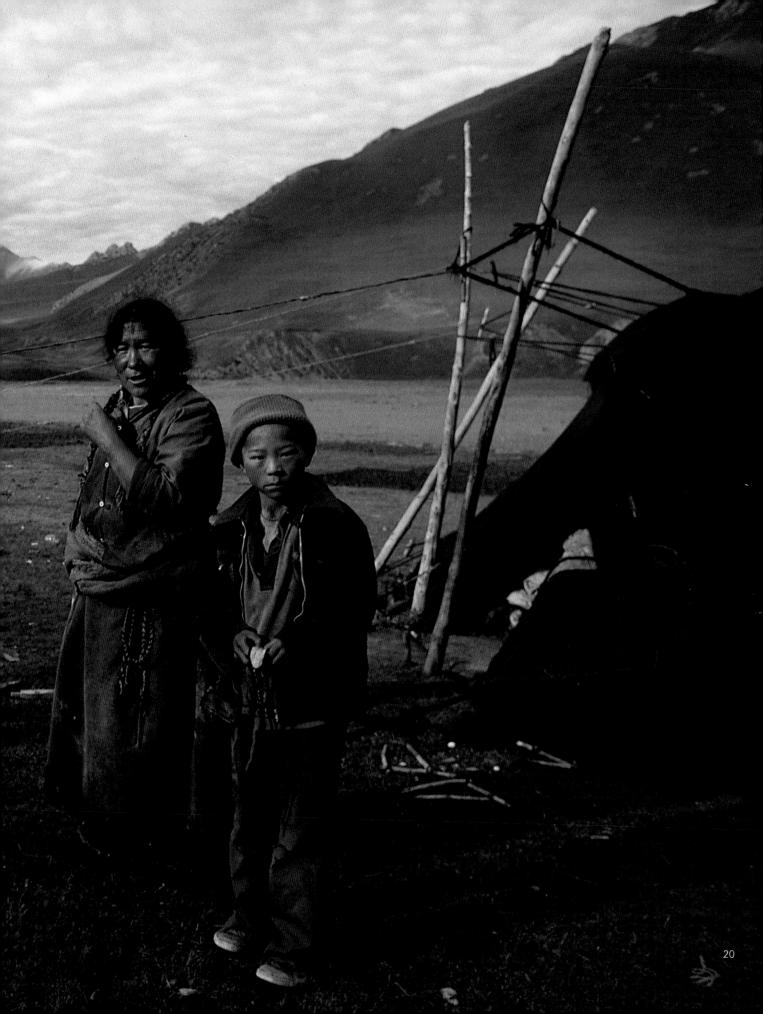

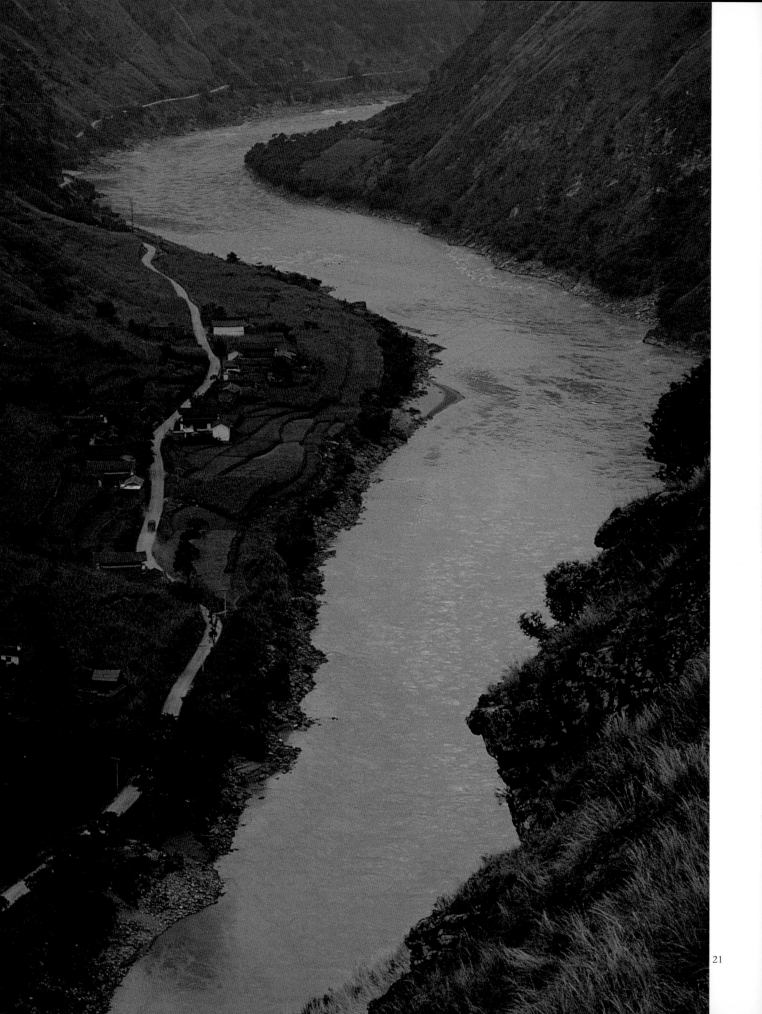

◄◄ 20

This family lives in a tent on the
outskirts of Zadoi, where they tend
their livestock: 100 yaks and 80
sheep. Tibetan tribes can be found
from Qinghai down to northern
Yunnan, where they farm. In the
summer, some grow mushrooms
for export. Q i n g h a i.

21

The Mekong, called the
"Lancang" in Yunnan, flows into
the canyons of northern Laos. In
Thai, "Lancang" means "one mil-
lion elephants." West Dali.

22

Jingding Temple is built at an alti-
tude of 10,600 feet on the peak of
Jizu Shan, also known as "Chick-
en-Foot Mountain." Shivering in
the cold, everyone waits for sun-
rise. The folds of this mountain
guide water to the Mekong.

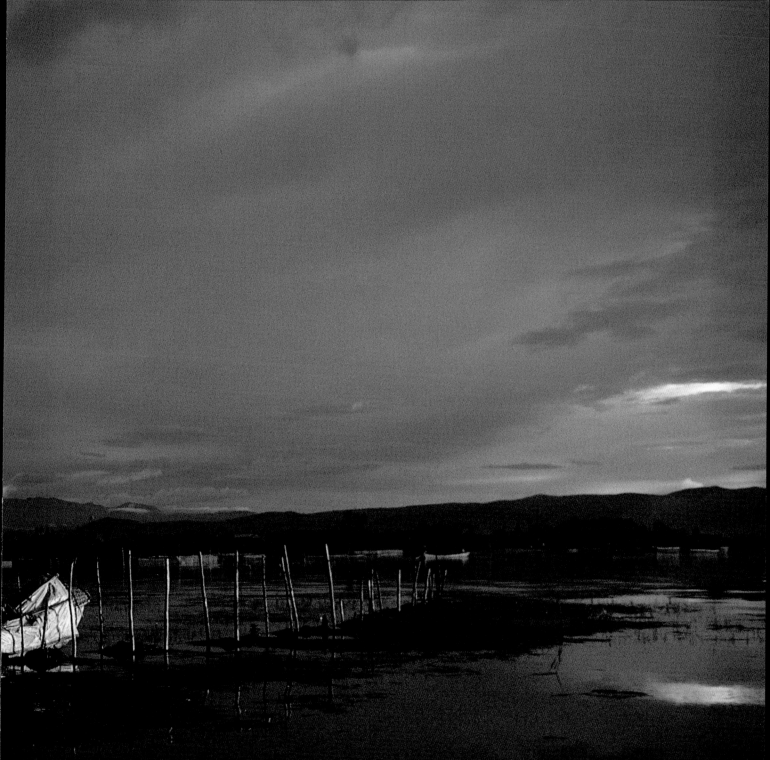

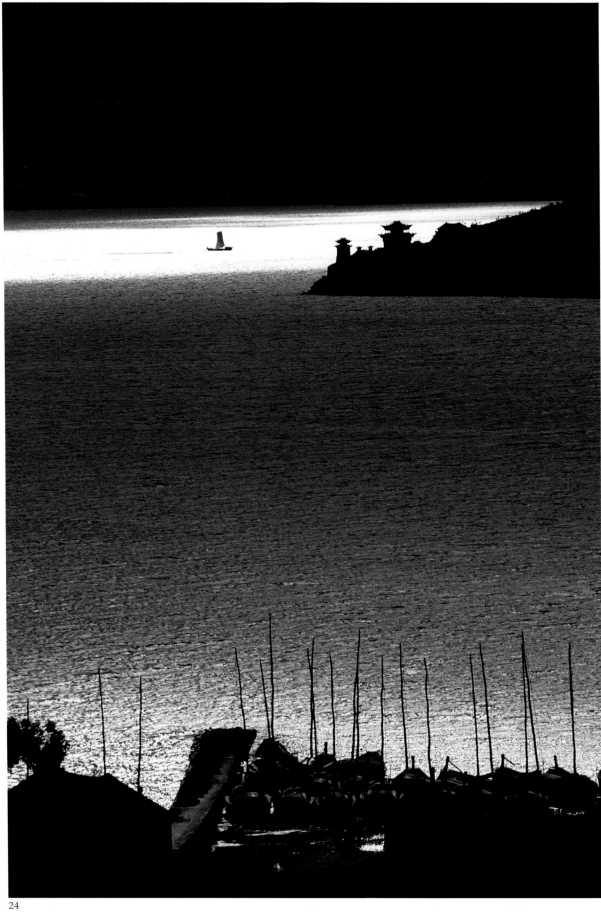

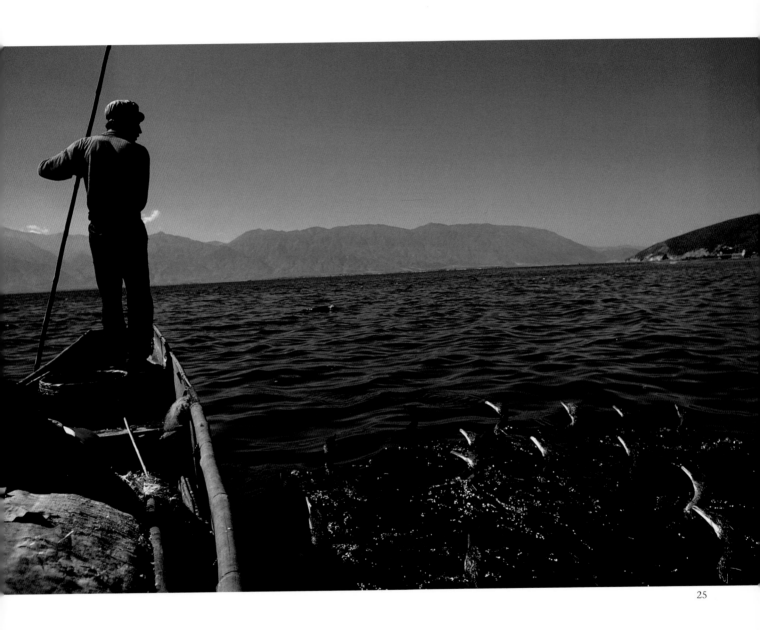

25

◄◄ 23
Erhai Lake, near Dali, is a tributary of the Mekong. Bai tribespeople paddle out in their small boats to collect fish caught in bamboo traps set the day before. Y u n n a n.

24
In the afternoon, the sunshine sparkles on Erhai Lake. Because the winds are so strong in this region, even motorboats are equipped with sails. Y u n n a n.

25
These cormorants are trained to fish. String loosely tied around their throats prevents them from swallowing their catch. The birds dive in response to signals, shouts and sounds made by striking the water with bamboo. Y u n n a n.

26

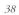
38

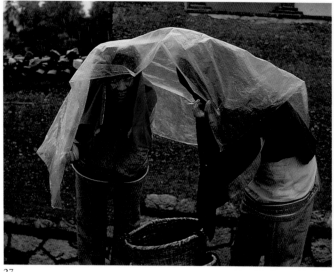

27

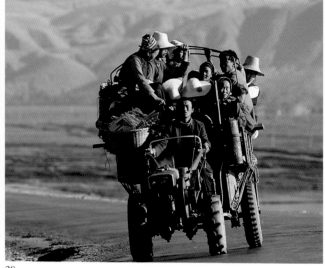

28

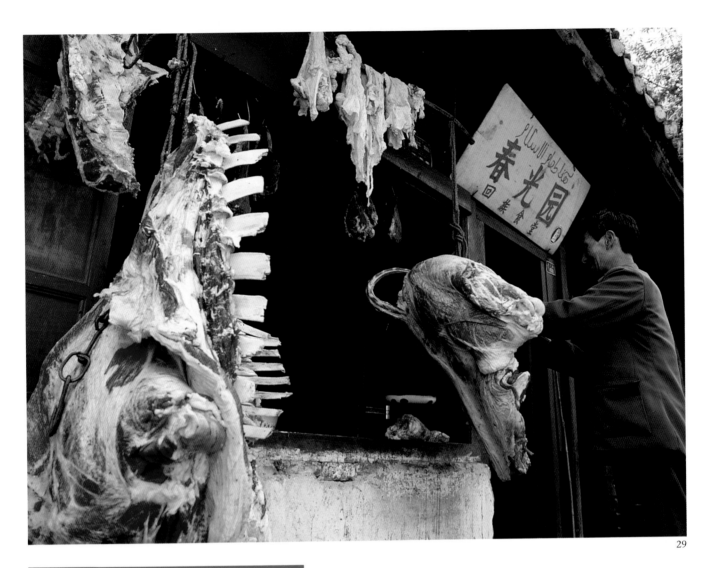

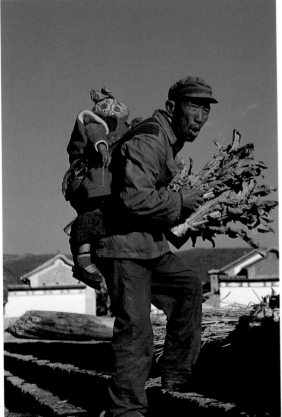

26
At the annual livestock market in northern Dali, squealing pigs are slaughtered and become ingredients for a spicy rice-noodle soup.

27
On a rainy day at the Dali Market, the ground turns muddy. Women here wear drabber clothes on rainy days, perhaps because they are easier to clean. Y u n n a n.

28
A tractor provides convenient transportation in rural Yunnan. Keeping one's grip on this vehicle when it's moving is no easy feat.

29
Some Hui Muslims live in Yunnan. On this street corner in Dali, beef is sold in front of an Islamic restaurant. Of course, pork is never served.

30
An old man carrying his grandchild on his back holds some of his crops. His people depend on water from Erhai Lake to wash their clothes and vegetables.

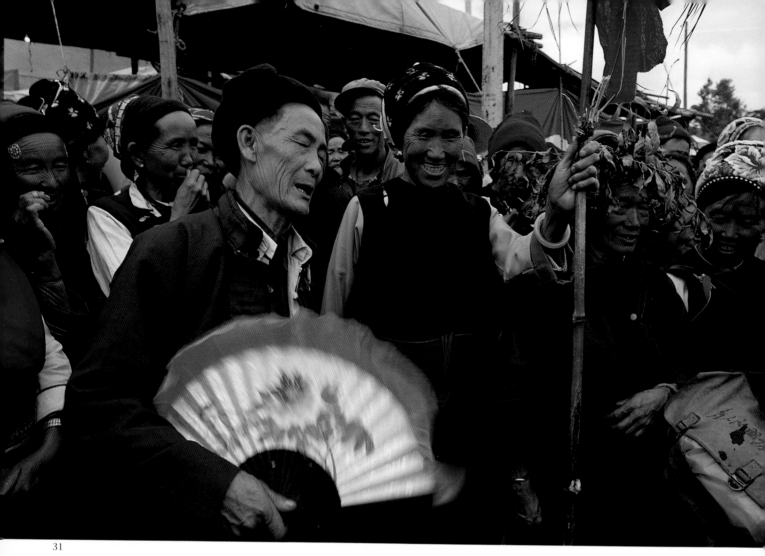

31

At the Raosanling Festival, people perform a *duige*, a kind of spontaneous singing dialogue. The content of these improvised duets ranges from comical to crude, and often provokes laughter.

32

The Bai people of Dali have regional fertility gods. In this shrine by Erhai Lake, old women are absorbed in chanting. Y u n n a n.

33

At each town's festival, the statue of the local fertility god is carried on a palanquin. Y u n n a n.

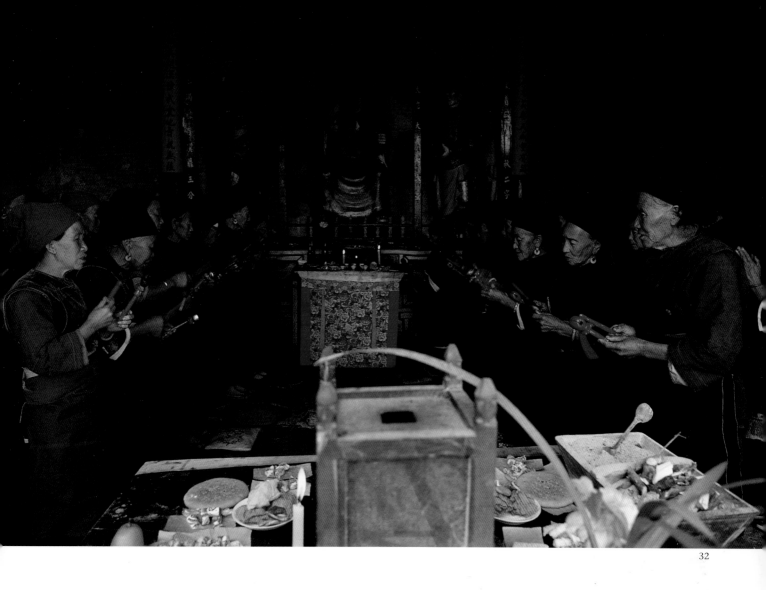

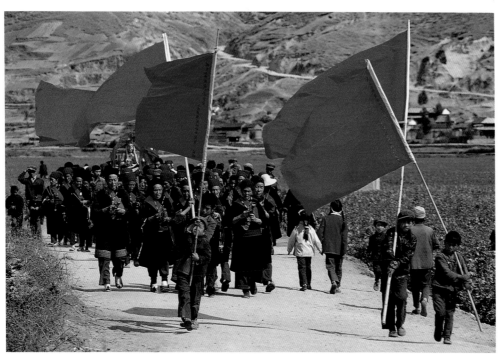

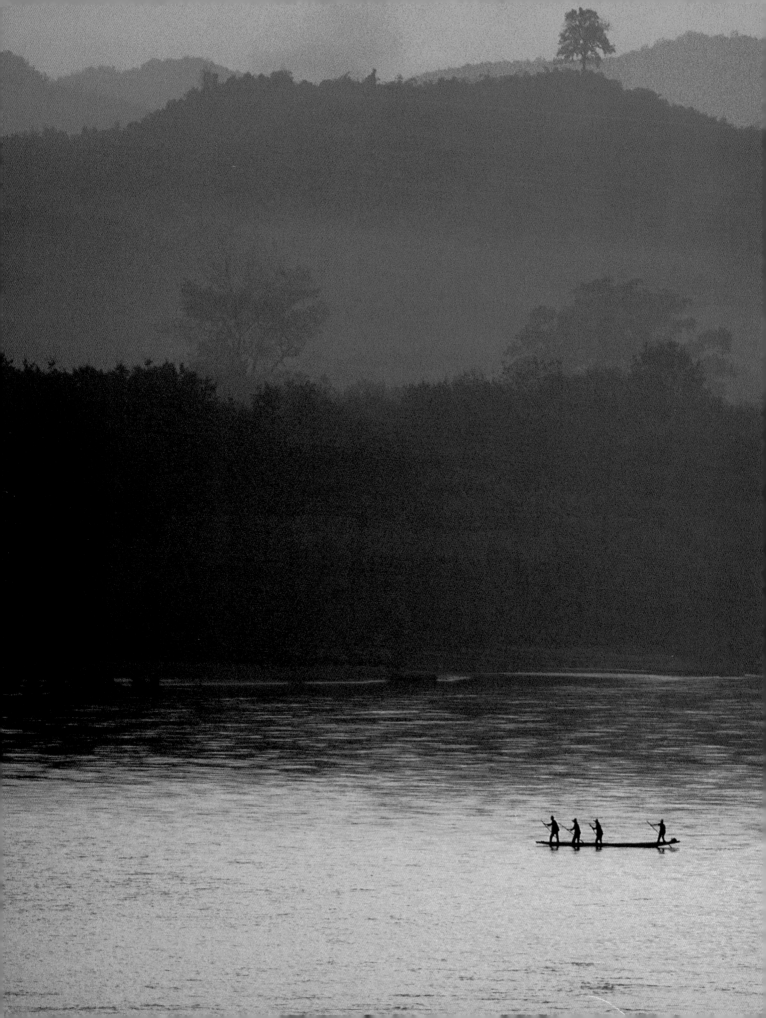

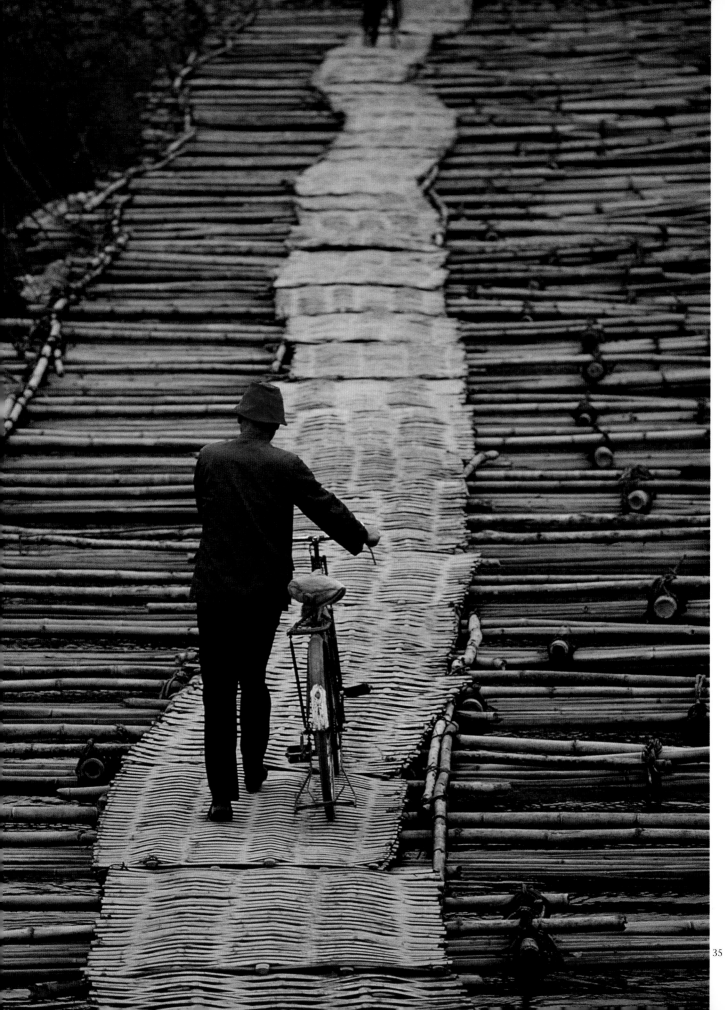

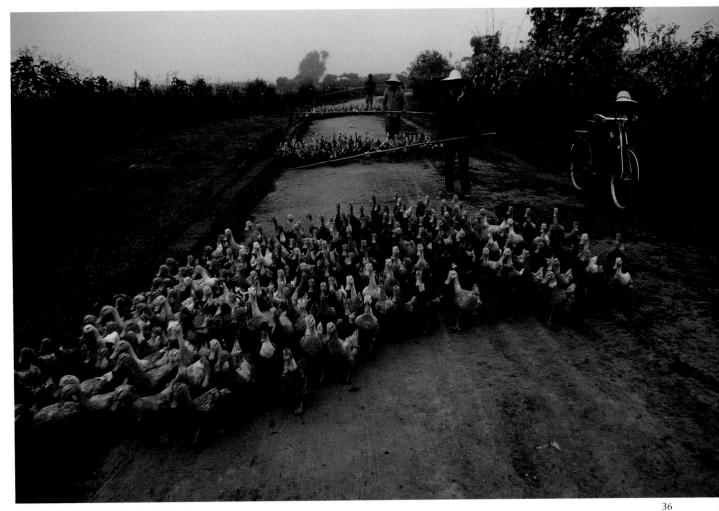

36

◀◀ 34

In the southernmost region of Yunnan, near Jinghong, Dai tribespeople cross the Mekong. The Golden Triangle is 150 miles south. In October, 1990, four small freighters made an unprecedented voyage down the Mekong from Yunnan to Vientiane, Laos.

35

Secured by wire, this bamboo bridge floats on the river.I smelled something horrible and realized a dead piglet was stuck on the bridge. Y u n n a n.

36

The Dai live in the lowlands near the river. Their livestock includes pigs, water buffaloes, chickens, and ducks, but they mainly rely on their rice crops. Both Thais and Laotians originally migrated from southern China, so they are distantly related to the Dai. Y u n n a n.

37

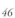

37
A Blang child carries a log chopped on the mountain. The slingshot around his neck is for shooting birds and animals.

38
An old Kongge woman burns this field to prepare it for planting corn and a kind of rice that can grow on dry land. Irrigated fields are extremely rare in the mountains.

39
This Blang village was built at an altitude of 4,900 feet. Mornings and nights are cold compared to those by the Mekong riverside. A Thai monk lives here in a temple.

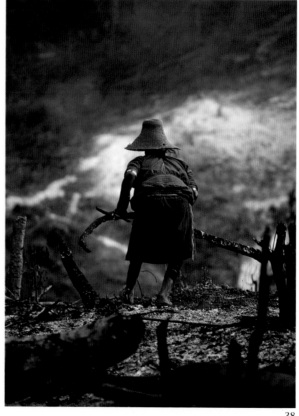

38

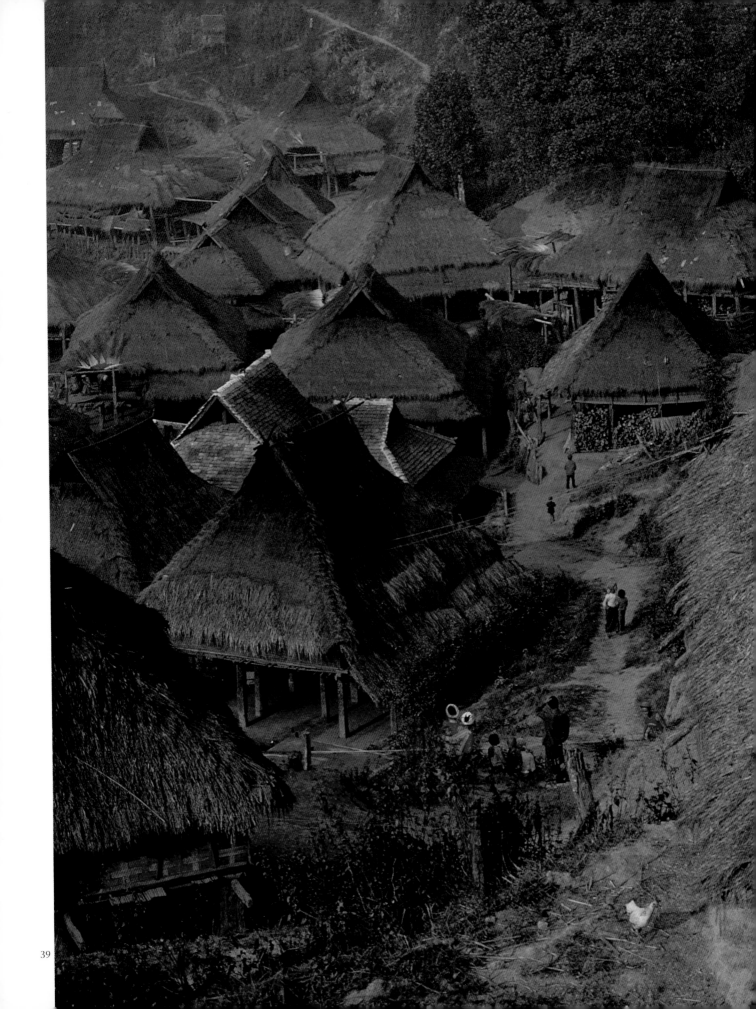

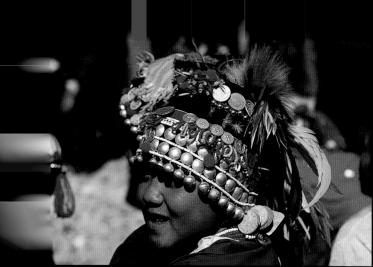

1 An Aini girl dressed up for a New Year's dance.

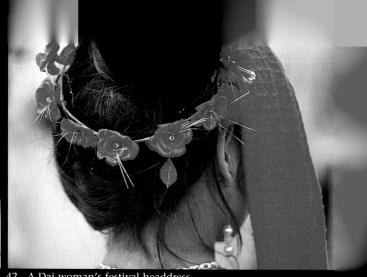

42 A Dai woman's festival headdress.

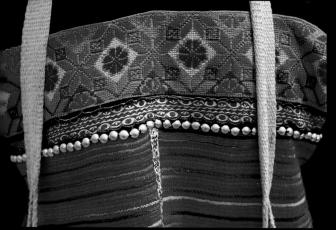

3 The back of a blouse worn by an Aku woman.

44 A Blang woman with huge earrings.

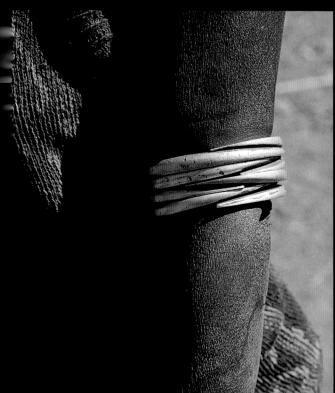

15 An old Va woman wearing a silver bracelet.

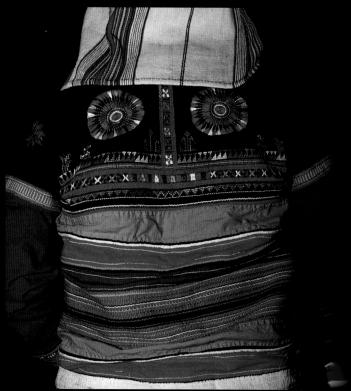

46 Jino women wear this blouse at festivals.

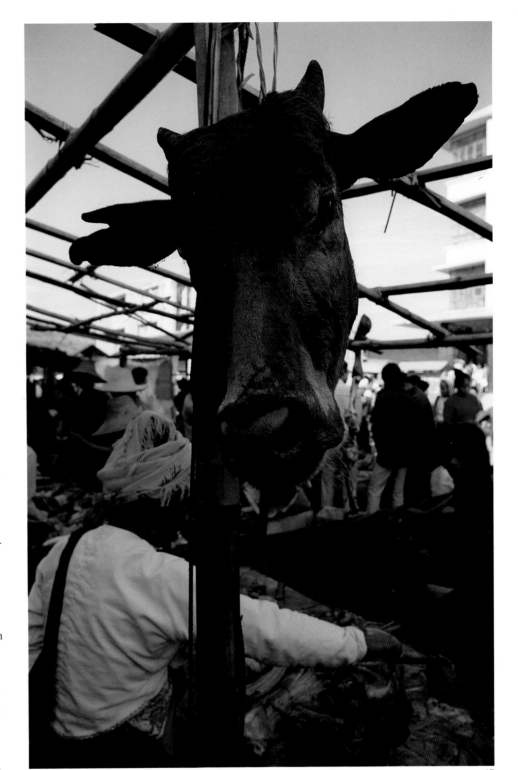

◀◀ 40

Kongge houses have high floors and sunken hearths. Water for cooking is brought from streams, in bamboo tubes. The Kongge people live in both Myanmar and China, but only approximately 900 remain in China now. The Chinese government does not recognize them as an independent minority. Y u n n a n.

41 to 46

In southern Yunnan, tribeswomen wear clothes embroidered with distinctive patterns passed down from their mothers. Traditionally, materials are cotton or hemp, but now colorful synthetic fibers are used. Younger women only wear such clothes for special occasions.

47

This cow's head is being sold at a market south of Jinghong, near the Myanmar border with China. Small tribes from both sides of the border frequent the market.

48

A Dai village on the outskirts
of Jinghong. On the morning
of the Water Splashing Festival,
women bring offerings of steamed
dumplings wrapped in banana
leaves, and pray to Buddha.

49

Larger Dai villages all have a
Buddhist temple. The statue
of Buddha in this temple is
being restored. From southern
Yunnan to Cambodia, Theravada
Buddhism is the main religion.

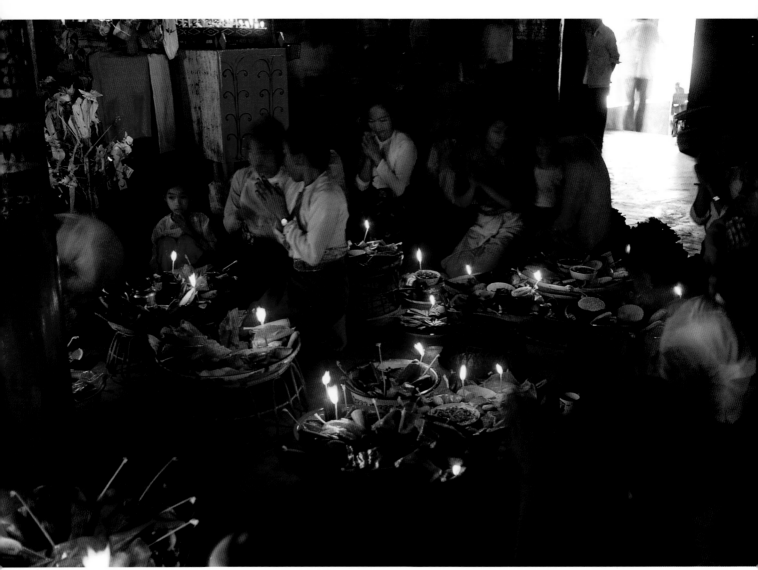

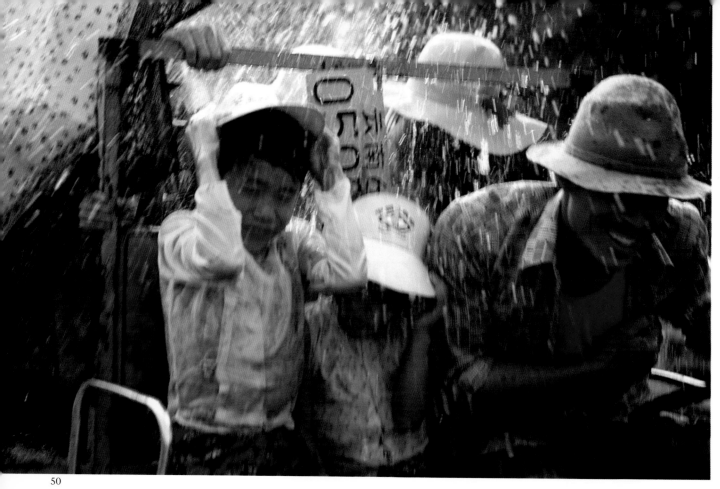

50

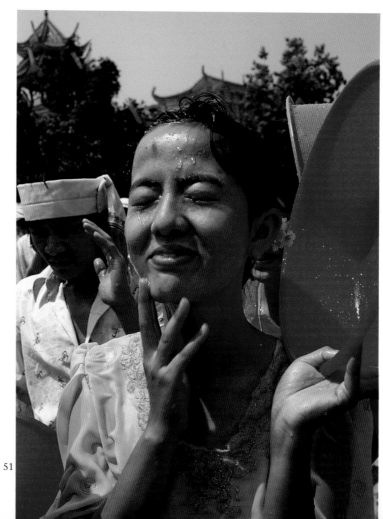

50

In the middle of April—the end of the dry season and the hottest time of the year—the Dai hold their Water Splashing Festival to celebrate the New Year.

51

On this day when splashing water on one another is permitted, formalities are set aside. Pretty women become targets. While I was absorbed in directing my camera at this woman, someone splashed me. Y u n n a n.

51

The three-day Water Splashing Festival in Yunnan includes dragon-boat races, cock fights, and bamboo fireworks. People celebrate the New Year by splashing water on each other. Water is considered the source of life, and the splashing ritual represents the giving and receiving of blessings.

Nowadays, there is not enough running water in town for the ritual, so trucks lined with plastic sheets transport it from the Mekong. Even Han Chinese and foreign tourists join in. Myanmar, Laos, Thailand, and Cambodia also celebrate the New Year with water splashing.

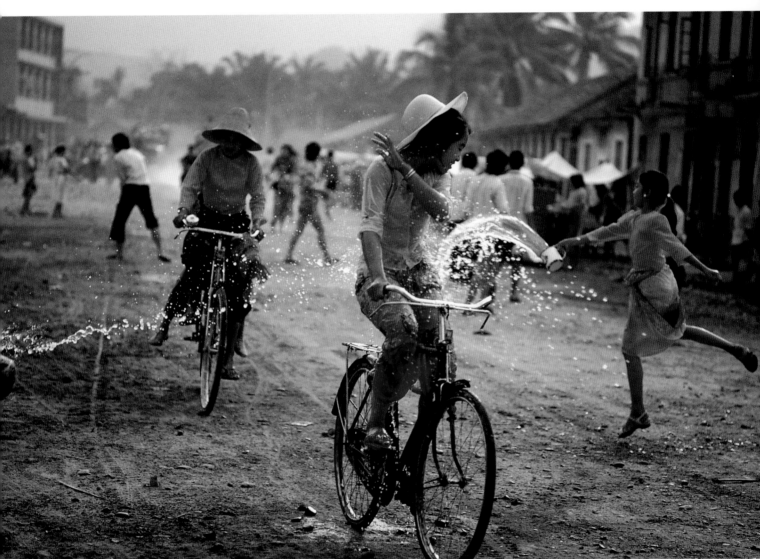

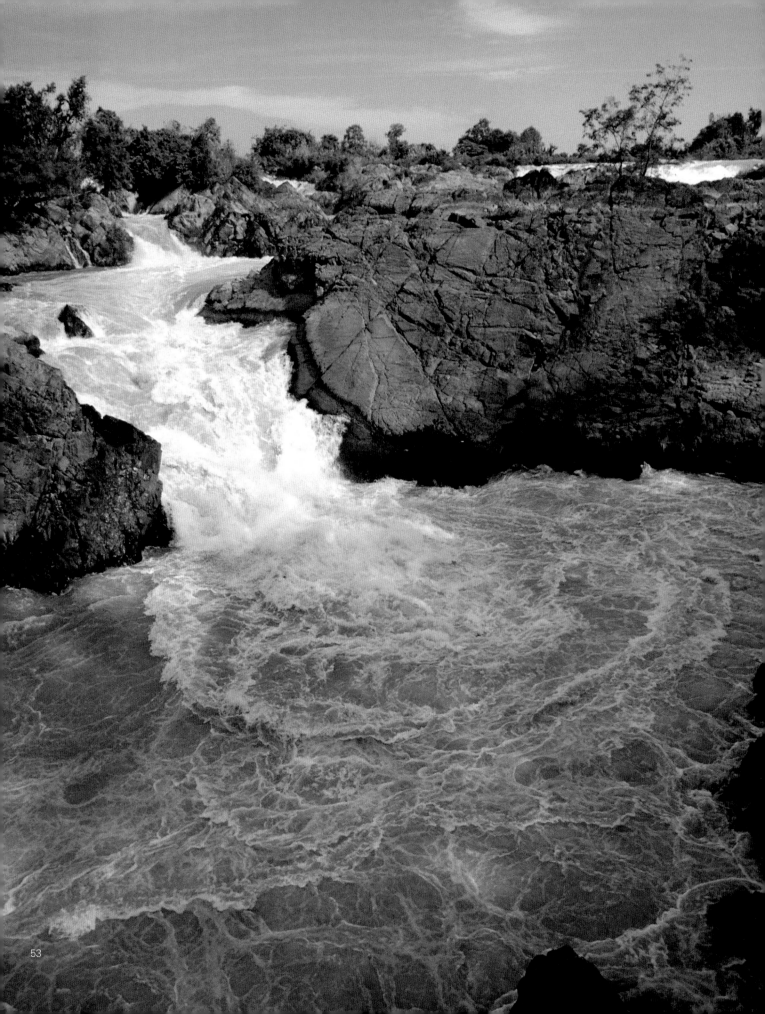

From the town of Pakxe, in southern Laos, I rode for four hours on a shaky bus which was in fact a remodeled Japanese truck. Then I took a small boat to Khong Island, located midstream in the Mekong River. Upon my arrival, I was welcomed by a brand-new, gold Buddha statue seated with Naga, the snake god, on its back. Khong Island is ten miles long and five miles wide, and has a population of five thousand. In the mornings, a small market is held there. Rice is grown in paddies, and fish are caught on the shores of the river. On Khong, one of the richer islands of Laos, clothing and medicine are the only items the inhabitants cannot provide for themselves.

As evening arrived, chasing away the heat of the day, I walked on the shore of the Mekong. Students rushing home on their bicycles passed me. By the riverside was a small sloping field which would no doubt be washed away when the river became swollen during the rainy season. A mother carrying her baby on her back plowed the field with a hoe, while a girl went back and forth carrying buckets of water from the Mekong and pouring them onto the field. Near them, two young women, who appeared to have been swimming, were washing clothes. Their wet black hair was tied up on the tops of their heads in the shape of a dumpling. As the bright red sun sank on the opposite shore, a man in a small boat cast his net into the river. Was he catching tonight's dinner? The net made a small splashing sound as it slipped into the water.

As I photographed these scenes, a group of men appeared. Ready to swim, they were naked from the waist up. They began teasing the young women at the riverside. They were probably warning them, "He's taking pictures of you." Without pausing to rest their hands, continuing to wash their clothes, the women smiled back at the men. One man said to me, "Go ahead, take their pictures, go ahead," pointing at them with his finger. Urged on, I pointed the camera towards the women once more and clicked the shutter. The men asked me, "Are they pretty?" to which I replied, "Yes, they are pretty." Then they shouted loudly, jeering, "He says you're pretty!" The women responded to this teasing with embarrassed smiles, but they didn't appear

From the Island of Joy

to the Waterfall of Ghosts

MIDSTREAM:
MYANMAR, LAOS,
AND THAILAND

53
The Somphamit Waterfall, in southern Laos, is also known as the "Li Phi Waterfall." The region is called "Four Thousand Islands" because of the way the numerous rapids break up the land.

ill at ease. I thought to myself, it's all right to lie sometimes, if it makes someone happy.

The next day I headed south from Khong Island to see Li Phi, a waterfall that is feared by many people. An educated travel agent I had gotten to know at Vientiane told me about it as soon as he discovered I was going to Pakxe. "You're going to Li Phi? There are many ghosts there. Everyone's very afraid. No one goes near. There have been photos taken there in which nothing came out! Be careful," he told me, smiling mischievously.

I was told, "No one goes near Li Phi," but this turned out to be an exaggeration. There were villages nearby, and local inhabitants fished at the waterfall.

Still, staring down at the pool beneath Li Phi, I felt as though I was being drawn in. The sound of the water crashing into the basin was incredible. I carefully descended the rugged rocks. Because of the spray from the falls, my footing became wet and slippery. I slipped slightly, and as I nervously regained my balance, I felt an eerie force pulling at my body. I wasn't convinced this was one of the ghosts people talked about, but I felt that something exceptional was lurking there.

Although the Mekong provides good fortune to many of the inhabitants on its shores, it is equally capable of destruction. There must be times when it floods that it takes human lives. The legend of the ghost of Li Phi reveals the inhabitants' conception of nature; they are grateful to the river, but they also fear it.

On Khong Island I met a native woman who fled the country after the Laotian monarchy was overthrown in 1975. "Living in another country was hard. I had to wake up early and work until late at night. But here I can take a nap if I feel drowsy, and if it's hot I can swim in the Mekong. There's no need to work so hard. Of course we have no disco or karaoke, but as long as you don't want those kinds of things, it's easy to find a happy life here."

She could make more money in another country, but she decided that Khong Island, her native home, was the most comfortable place to live. She chose to spend the rest of her life here, where one lives intimately with the river.

54
A tributary of the Mekong leads
to the city of Keng Tung. Until the
1960s, this region was ruled by the
Sawbwa lords of the Khun people.
Numerous Theravada temples give
the city a peaceful atmosphere.
M y a n m a r.

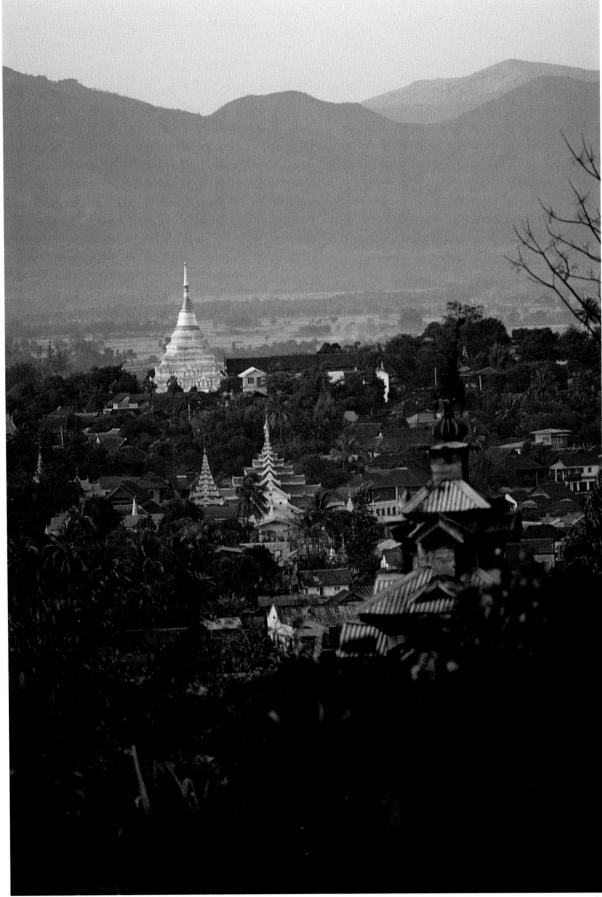

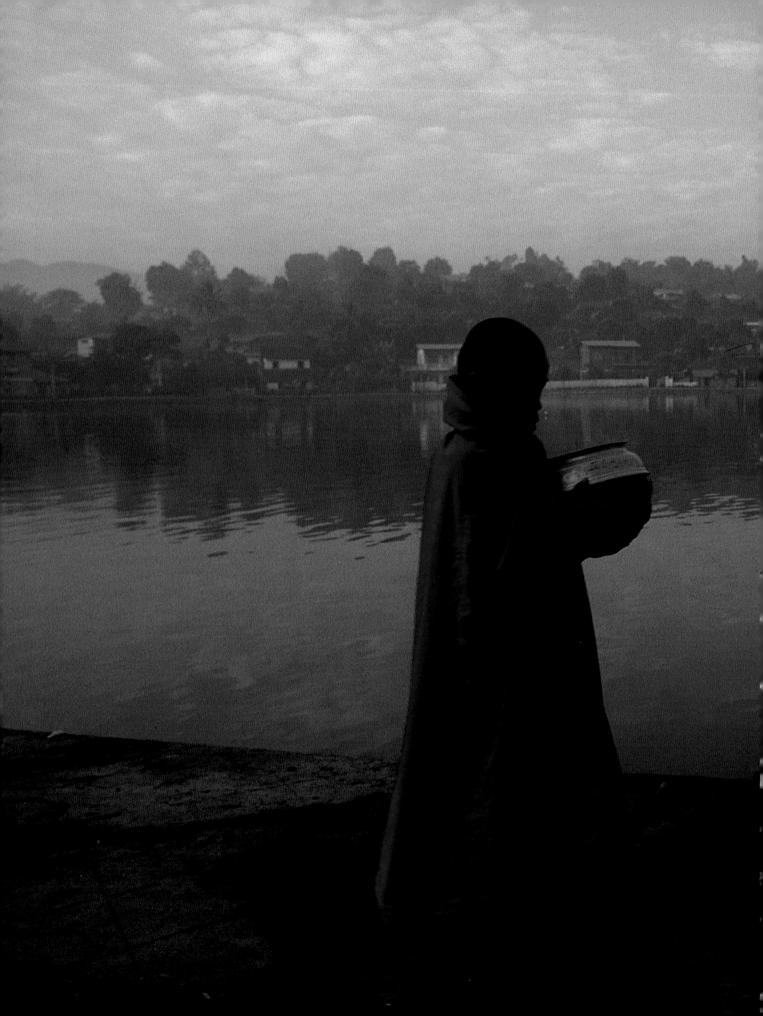

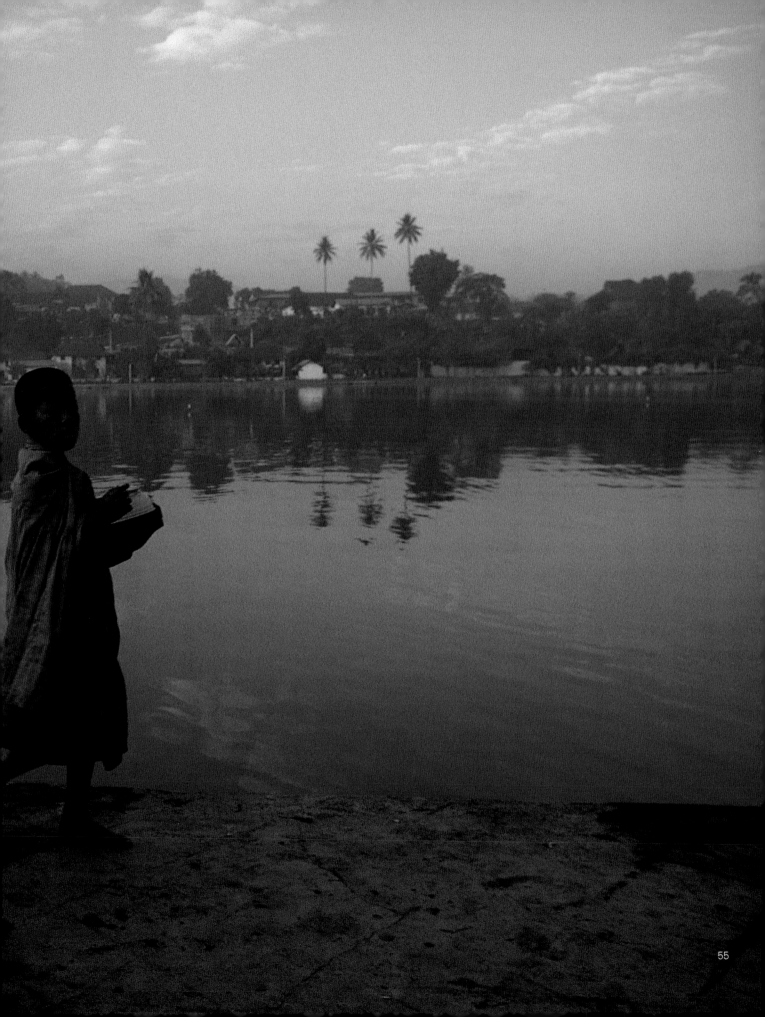

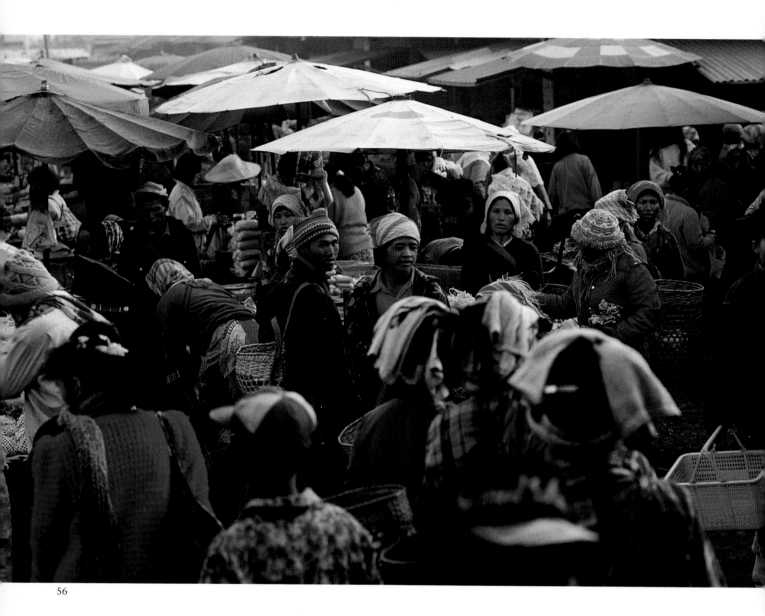

56

◄ 55
At Naungtung Lake in the center
of Keng Tung, a child monk asks
for alms. In sharp contrast to the
calm of this early morning, the
previous night, at the disco float-
ing on the lake, girls in miniskirts
danced and sang karaoke.

56
Over ten tribes, including Shan,
Burmese, and Chinese, attend
the Keng Tung Market, one of
the busiest in the Mekong region.
Most consumer goods are import-
ed from China and Thailand.

57
In this game of chance, gamblers
bet on animals in hopes of dou-
bling their money. At the south-
ern border of Yunnan, numbers
are substituted for animals.

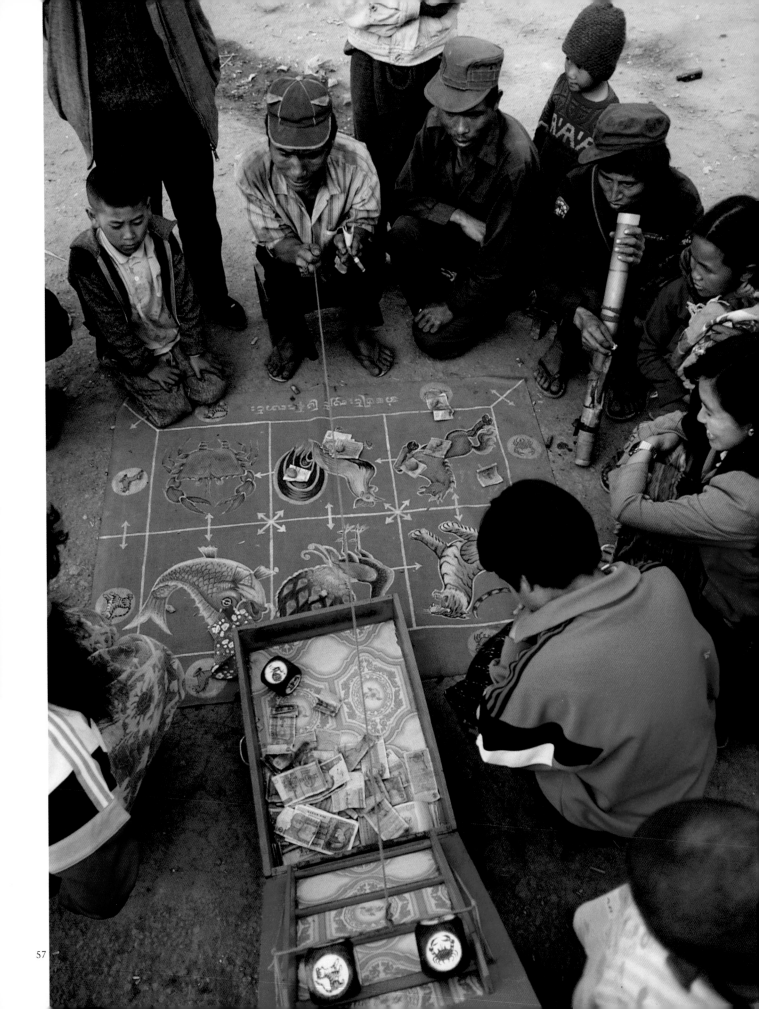

57

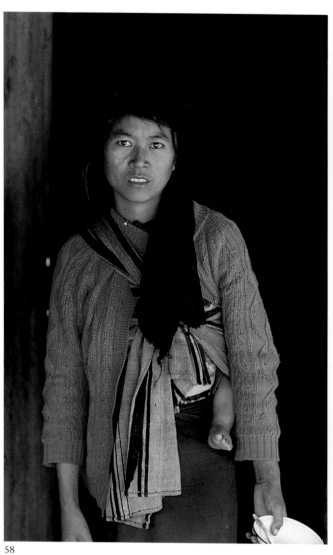

58

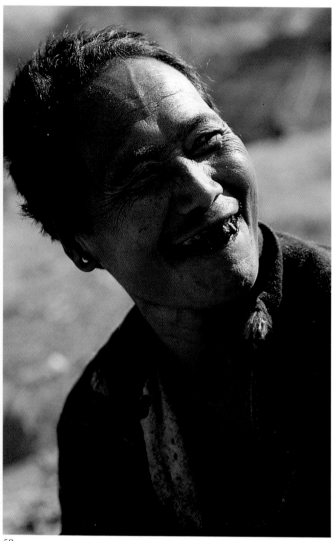

59

58
A Va mother. The Va live in
Yunnan and Myanmar and
speak a Mon-Khmer language.
Long ago, they were head-
hunters. M y a n m a r.

59
This man's teeth are completely
black from chewing betel nuts
and tobacco. He offered to let me
shoot his old musket—for a price.

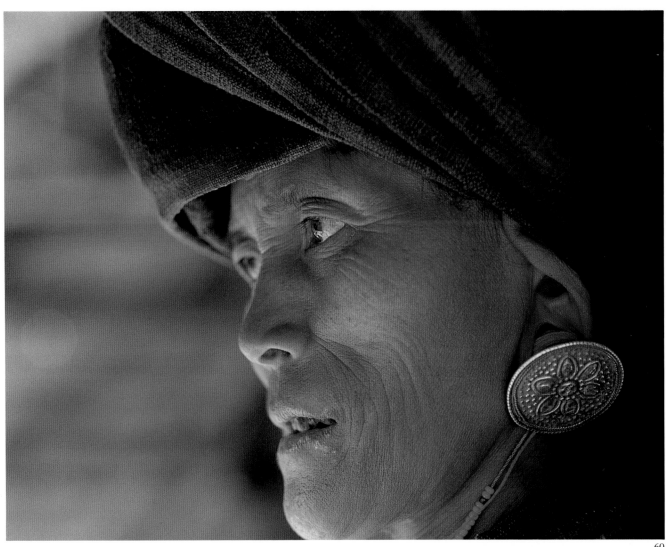

60
The weight of this Aku woman's silver earrings makes her earlobes droop down. Her village, which has converted to Christianity, has a small church. The Aku speak Tibeto-Burman. M y a n m a r.

61

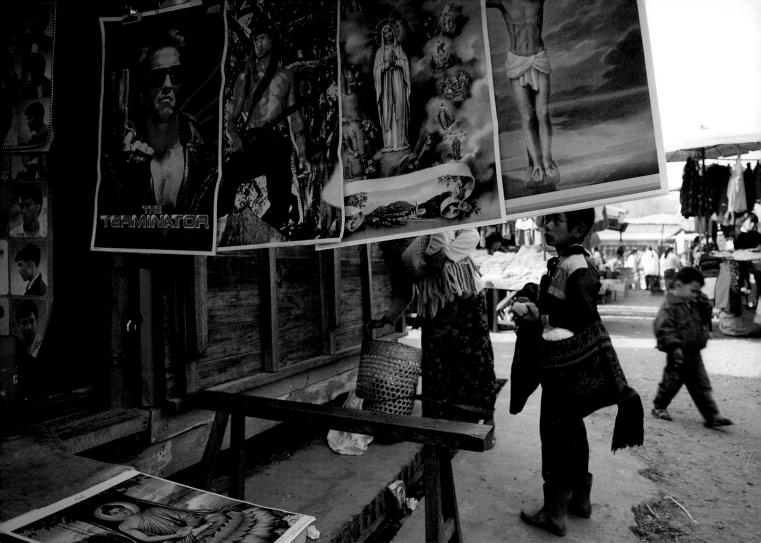

61

This man sells cigars in Keng Tung.
Myanmar is the only country
along the Mekong where I saw
cigars. The people of Myanmar
believe in Theravada Buddhism
and indigenous gods. Some carry
mementos of their high priests,
who they believe can work mira-
cles. This man treasures a picture
of a deceased high priest.

62

The Khun and Shan peoples of
Keng Tung are related to Thais,
and once had strong connections
with northern Thailand. This town
has prospered because its market-
place provides a meeting point for
the tribes of the flatlands and
those of the mountains. The vari-
ous posters in this photograph
are imported from Thailand. This
boy is gazing at a picture of a Thai
model wearing a swimsuit.

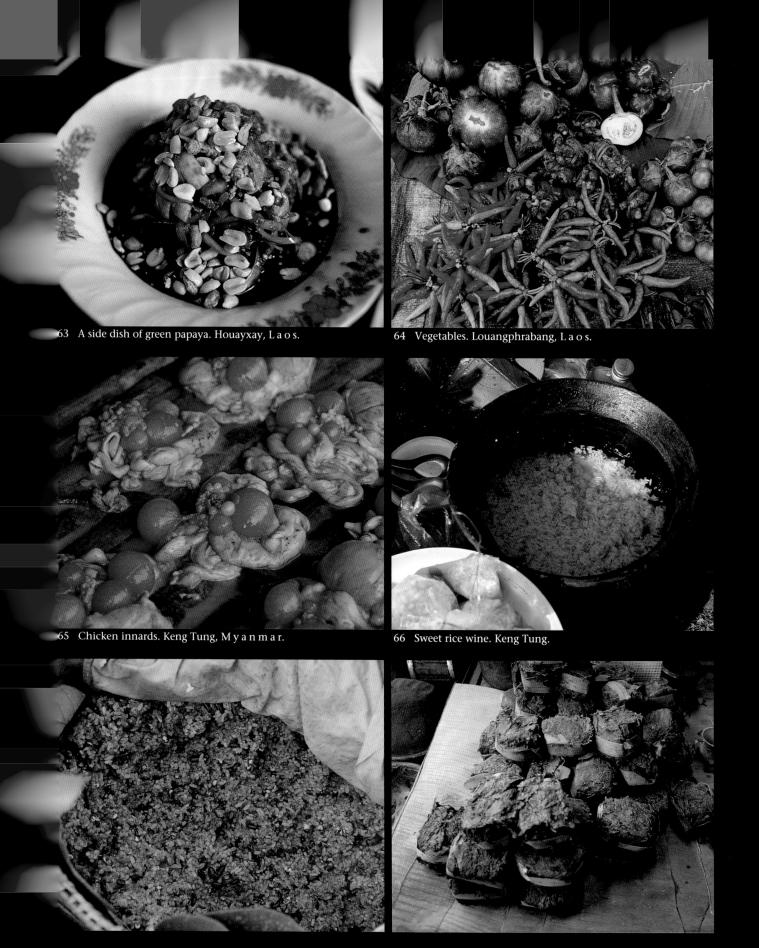

63 A side dish of green papaya. Houayxay, L a o s.

64 Vegetables. Louangphrabang, L a o s.

65 Chicken innards. Keng Tung, M y a n m a r.

66 Sweet rice wine. Keng Tung.

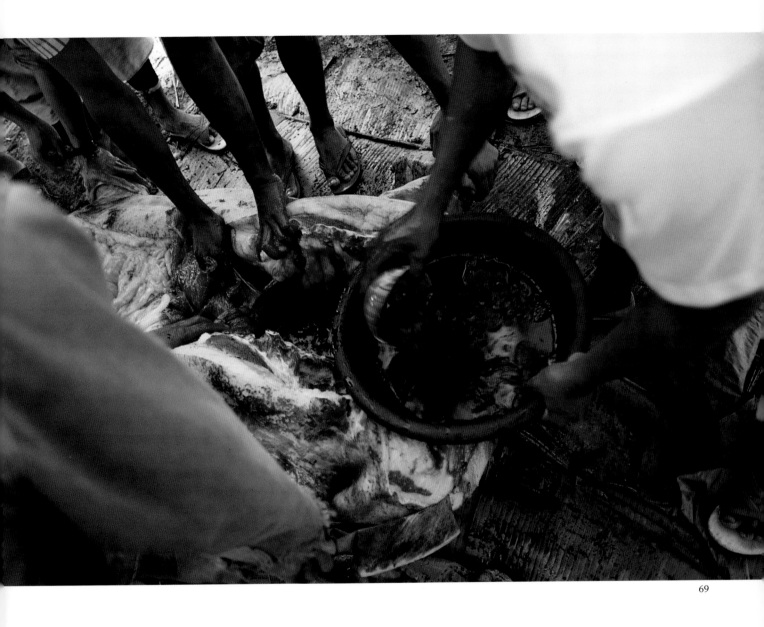

69
The Lisu people celebrate the
Chinese New Year. They eat a
New Year's meal, drink rice wine,
and dance late into the evening.
I saw several men who had been
smoking hemp or opium discharge
their guns. A pig was slaughtered
the following morning, and its
blood was saved in a bowl to be
eaten after it had solidified.

70

The white flowers of tobacco
grown by the Mekong are in full
bloom in January. The leaves are
harvested and dried with coal fires.
Chiang Khong, T h a i l a n d.

71

The Thai government is working
hard to eradicate the narcotics
trade in the Golden Triangle, but
there are still poppy fields in
northern Thailand. A local guide
led me through a grove to this

one. The fluid extracted from
poppy bulbs can be refined into
heroin. A local inhabitant told me,
"This is also part of our culture,
so if you don't try some you won't
understand us." T h a i l a n d.

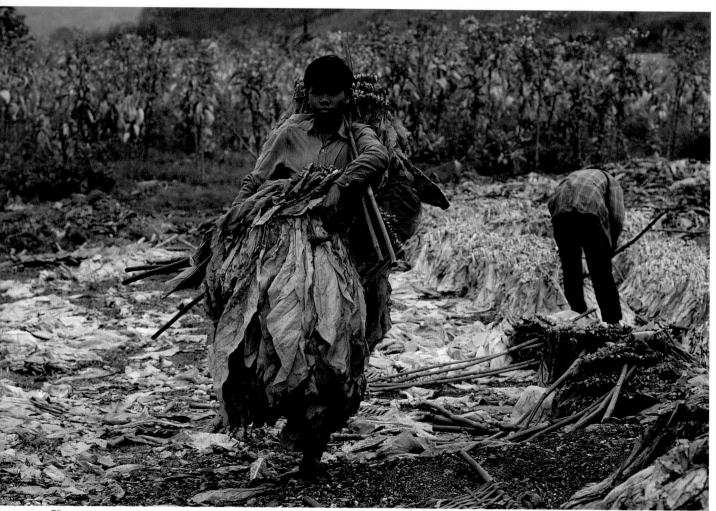

73

Louangphrabang was the capital
of the first Laotian kingdom,
Lane Xang, established in 1353.
From the hills of Phousi, near the
Mekong, I heard children's shouts
echoing, and discovered a row of
houses surrounded by palm trees.

74

A dock at Louangphrabang.
Because rural Laos has no
reliable roads, boats are vital
for transportation. Some travel as
far as Vientiane or Chiang Saen,
Thailand. L a o s.

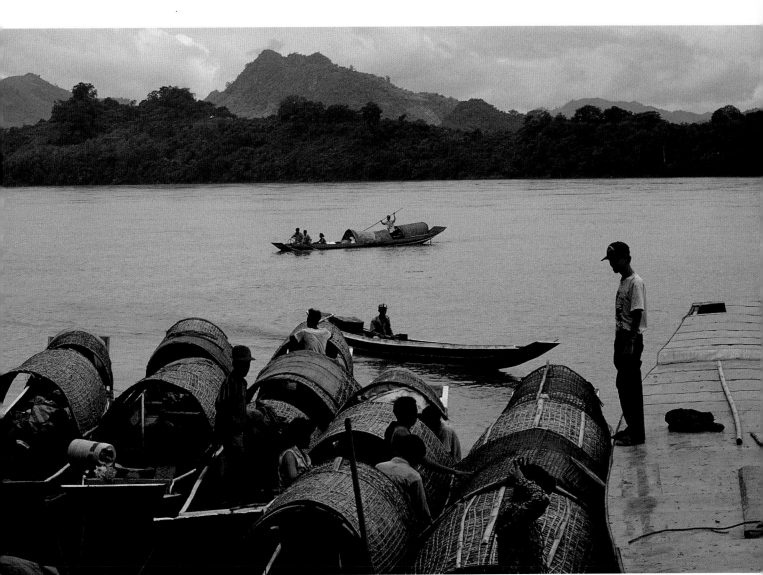

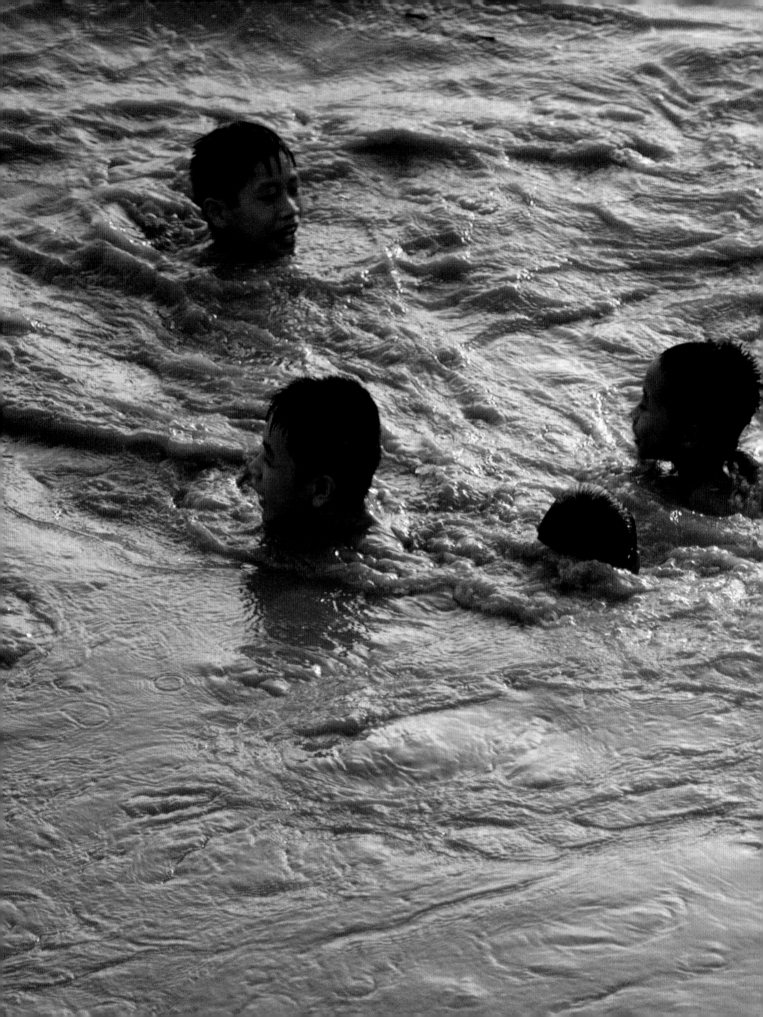

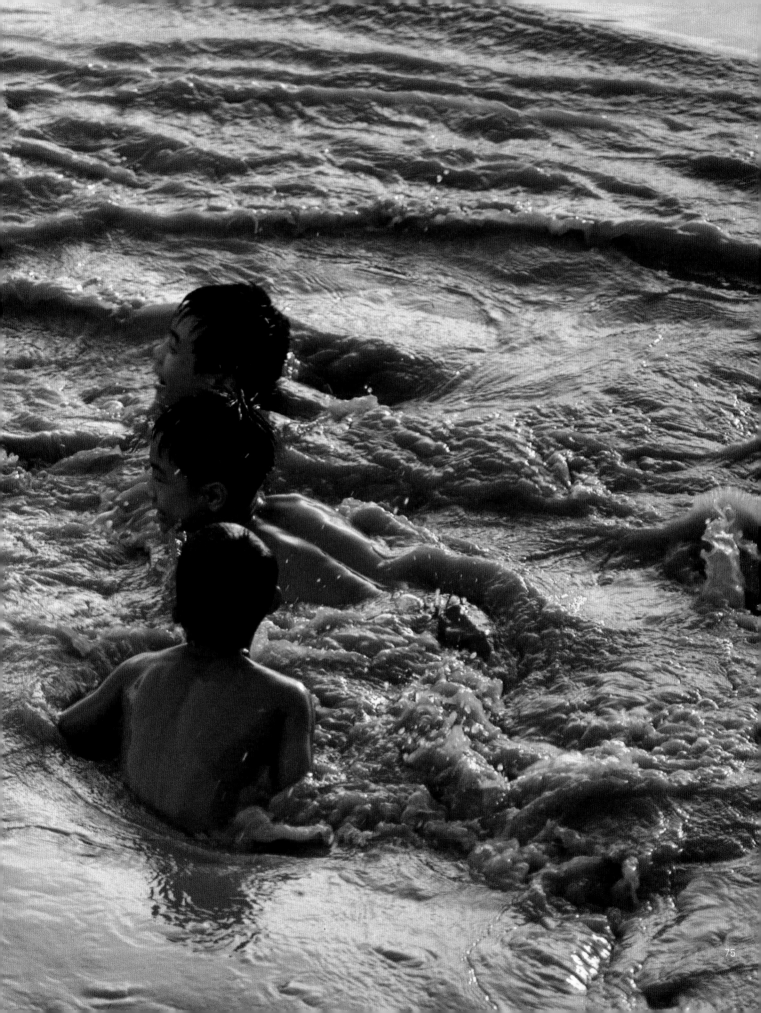

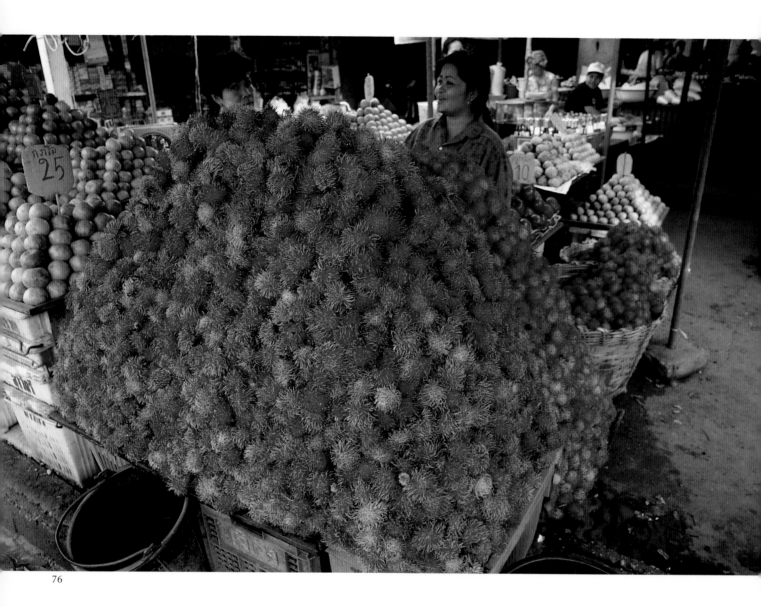

◀ 75

These children are swimming in
the Mekong at Houayxay, where
Thailand and Laos meet. I saw a
border guard bathing near them.
This peaceful sight would have
been unthinkable when these
countries were at war.

76

At the market of That Phanom, in
the Buddhist holy land of north-
eastern Thailand, a mountain of
local fruit is sold at a low price.

77

The Mekong region has two seasons: the dry season and the rainy season, which lasts from May to October. In Vientiane, in the afternoon, a sudden storm arises.

78

The residents of Savannakhet, Laos, a town 280 miles downriver from Vientiane, watch Thai television programs transmitted across the river. In this video store most of the videos are in Thai.

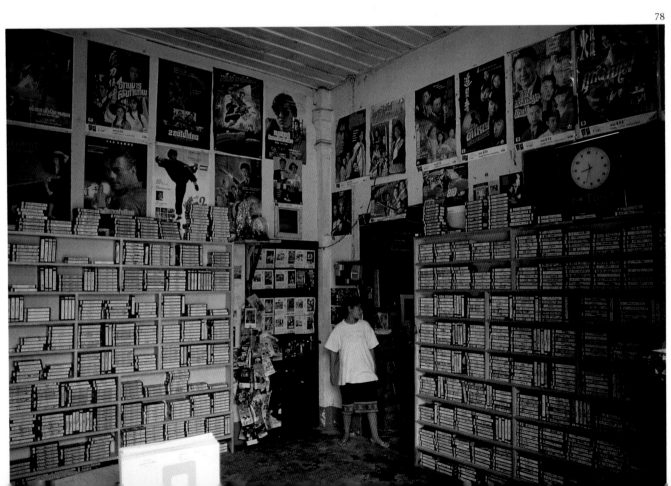

78

79

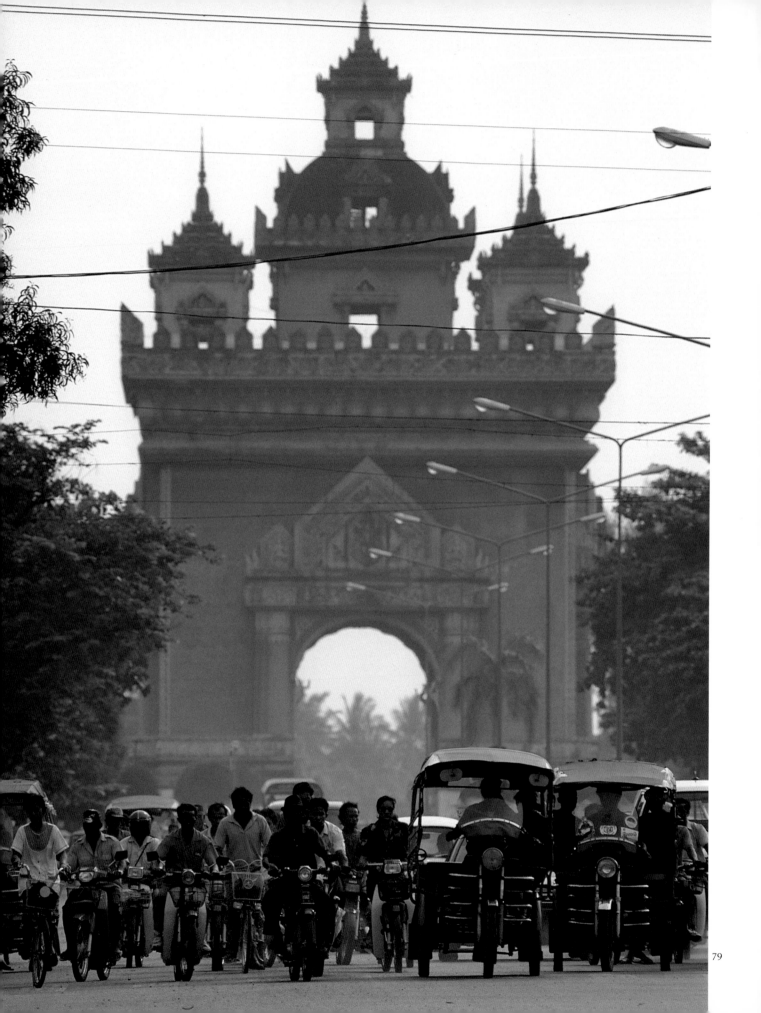

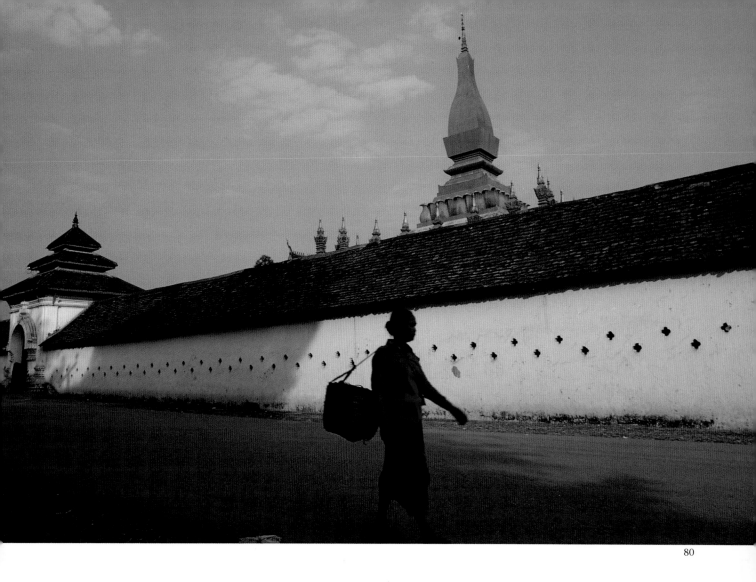

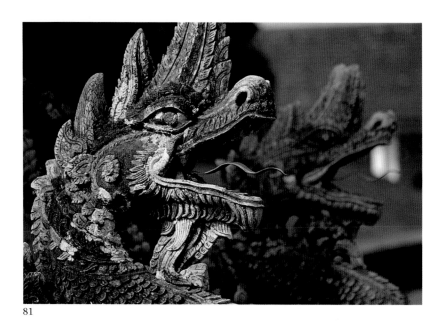

81

79

This monument commemorating Lao's independence is a Vientiane landmark. L a o s.

80

The tallest stupa in Laos is That Luang. Built in 1560, when King Setthathirat made Vientiane the capital of his kingdom, That Luang is 150 feet tall. L a o s.

81

A pair of dragons crouch at the foot of the stairs inside That Luang. In Laos, the dragon is considered the god of rain. L a o s.

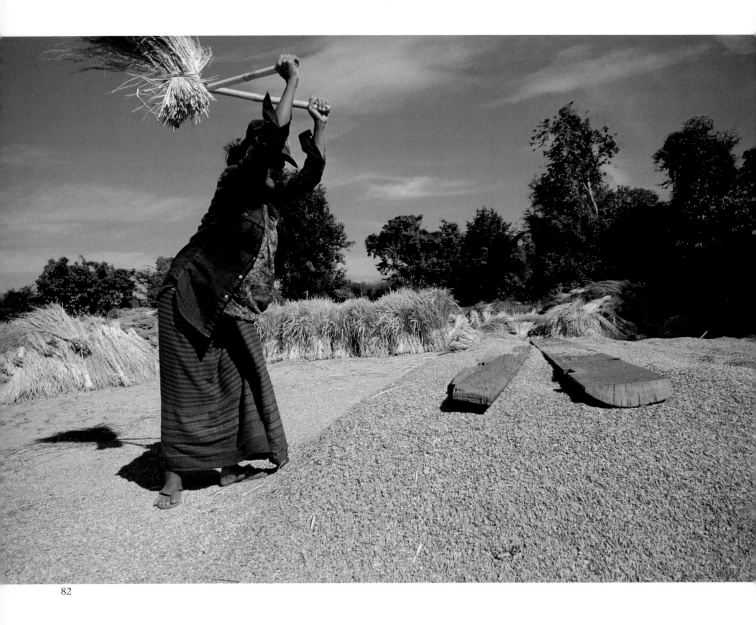

82

82
Khong Island, located near the
border between southern Laos
and Cambodia, is the largest of
the "Four Thousand Islands." This
person is threshing Khong rice by
hand against a board. L a o s.

83
Two brothers return home in the
evening after swimming. Because
the inhabitants of this peaceful
island hardly ever encounter the
gaze of a foreigner's camera, these
boys are frightened and quickly
run away. L a o s.

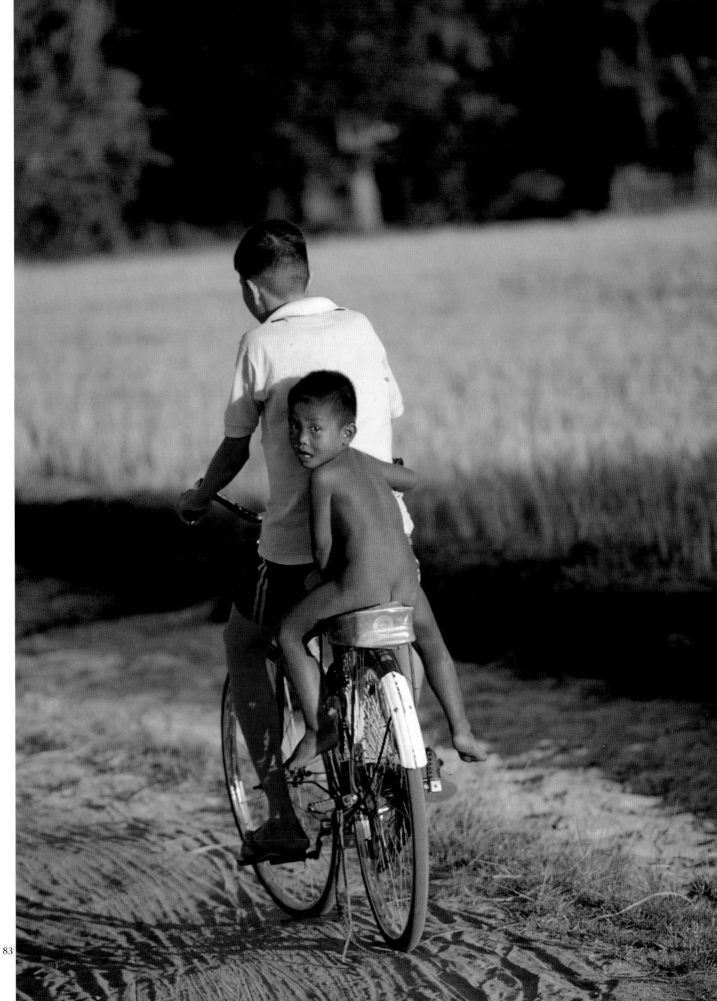

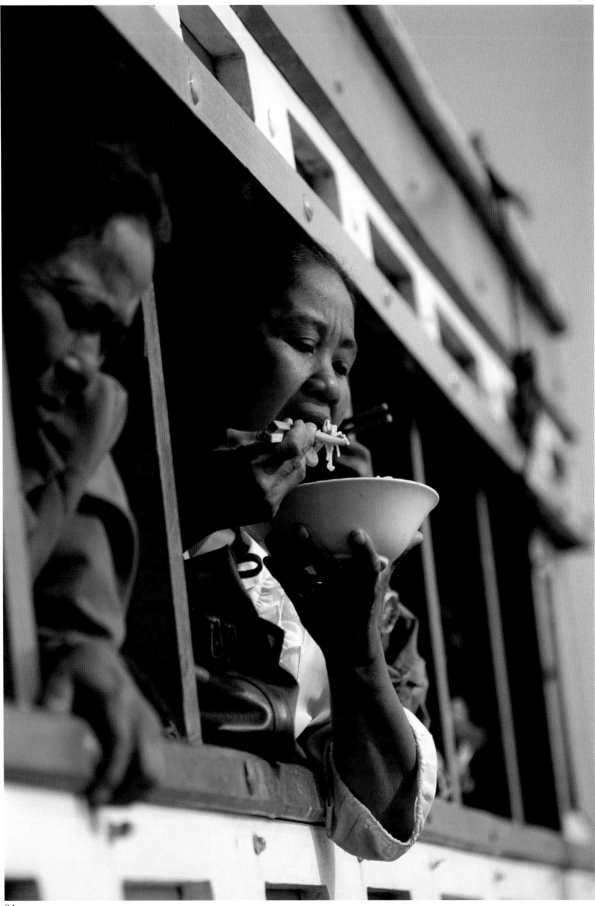

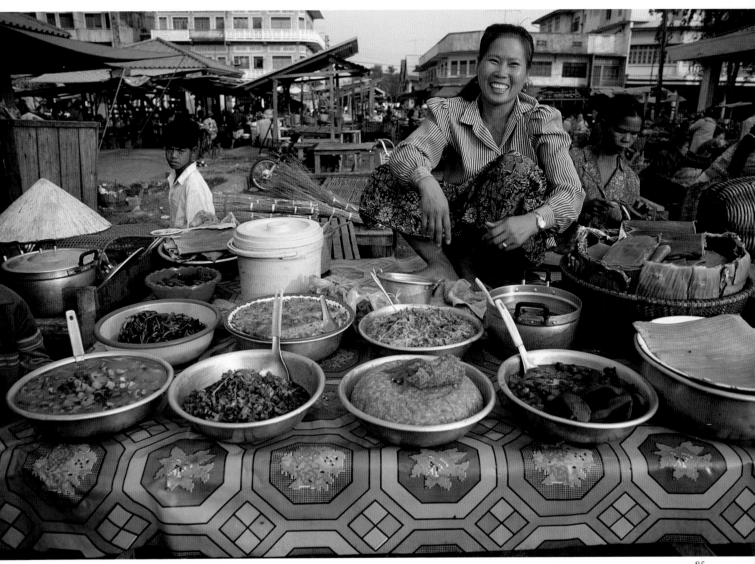

84
The public bus that serves Pakxe
in southern Laos is a remodel-
ed Japanese truck. To cross the
Mekong, the bus boarded this
ferry, which departed slowly
from the riverside. The passen-
gers are savoring rice noodles.

85
A traditional Laotian rice dish
with side dishes. Life in Pakxe
revolves around the Tallat Market,
where everything imaginable is
sold. L a o s.

86

The local people now use the
ruins of Wat Phu, a Khmer temple
built in the eleventh century, as a
Theravada temple. A statue of the
Buddha consecrates the shrine.

87

As February approaches, Laos's
national flower, the plumeria,
blooms everywhere, exuding a
sweet smell. The Mekong is about
two miles from this spot. L a o s.

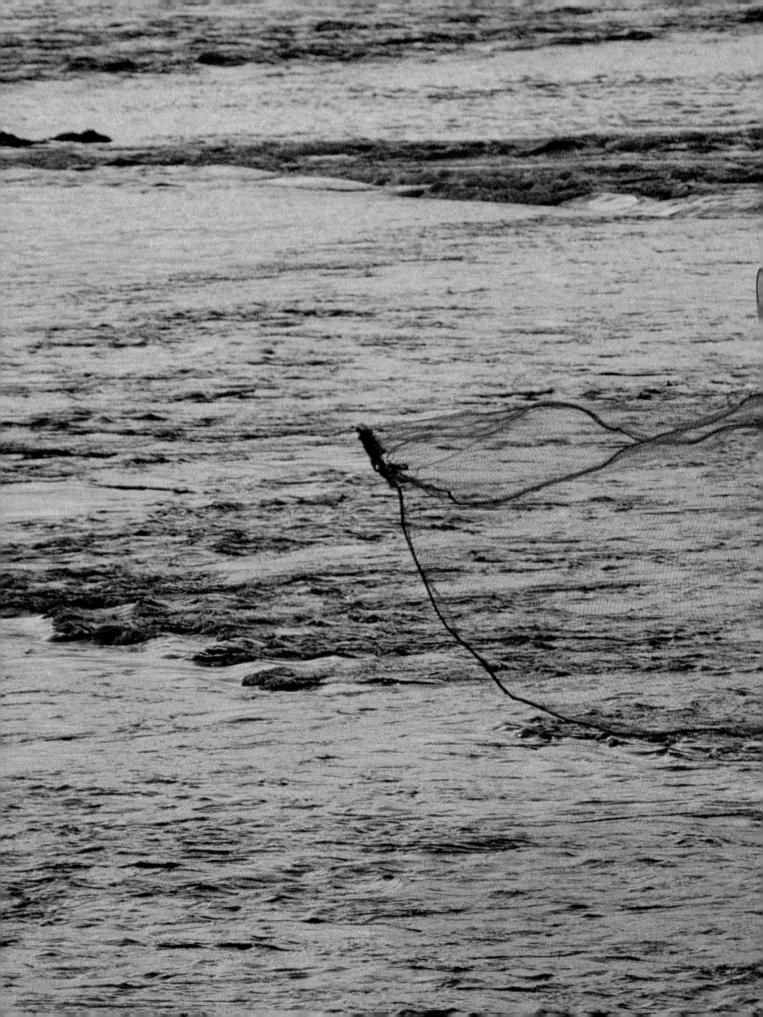

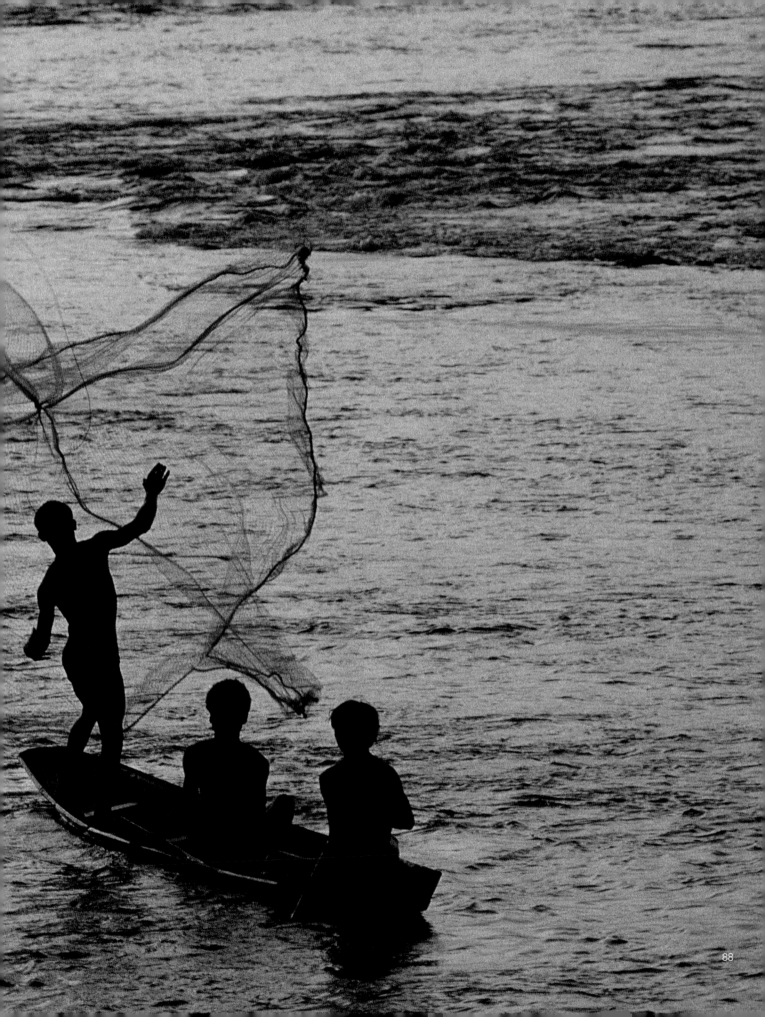

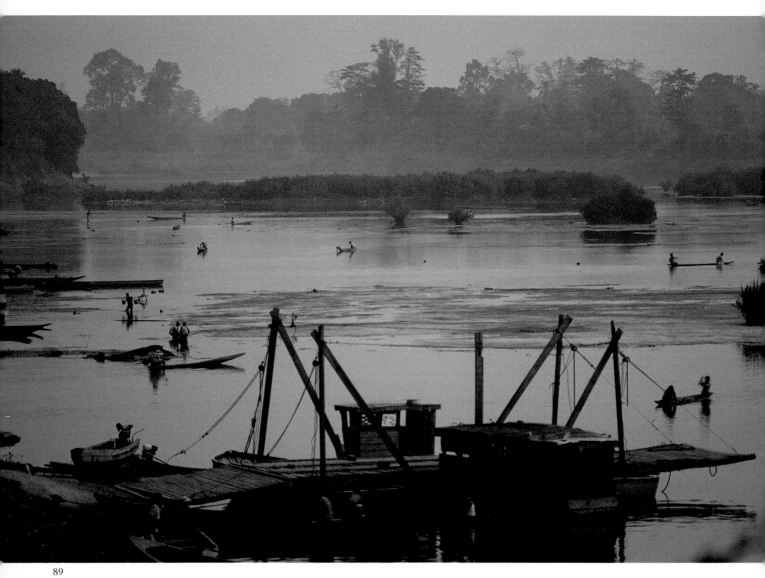

89

◄ 88

The first bridge ever to span the
Mekong from Laos to Thailand
was built in April of 1994. This
construction heralded a new phase
of development for the Mekong.
However, on the outskirts of Nong
Khai, these people are still fishing
with traditional methods.

The road to the Mekong River was teeming with people. Following traffic regulations, everyone left their motorcycles and pedicabs behind, and walked toward the festival grounds.

Each year at the onset of the dry season, when the fishing industry begins to thrive, the Water Festival is held at Phnom Penh. In the main event, the crews of boats who have won various regional competitions gather to race against each other. The Water Festival is held to express everyone's gratitude toward the Mekong for providing food and fish in abundance.

As the native Cambodian music for the race began, the first boat became visible upstream. In each heat, two or three vessels raced about a mile in approximately three-minute intervals. The lively boats sprang forward like animals. Following the rhythm of the gongs and drums, forty-two arms rowed their oars against the water, while the person at the bow danced, twisting his arms and legs. The water splashing from the paddles gleamed in the sunlight. The spectators, who had been sitting quietly, suddenly stood up, waved their fists, and shouted at the top of their lungs, cheering on their respective local teams. Drawn into this atmosphere, I too lost myself in the race.

Painted on the bow of every boat was a pair of eyes, gazing fiercely at the river. The boats symbolize Naga, the snake god, and the eyes are said to be his. In China, the Naga of the Indochinese peninsula is called a dragon, but all the frequently encountered dragons and Naga of the Mekong region are gods that provide rainwater for the inhabitants.

Numerous carts sold snacks and refreshments, and young couples and families sat in circles on mats, eating dried squid or boiled eggs, and drinking beer adrift with ice cubes. Playing children hung from the rope of a balloon that advertised soft drinks. A man who had lost his leg to a land mine placed his hat in front of him and begged for help from passersby. On the makeshift stage, a pop band played some cheerful, buoyant music while a group of teenage boys

Enchanted by
the Dragon-Boat Races

DOWNSTREAM:
CAMBODIA AND
VIETNAM

92
The eyes of Naga, the snake god, are carved on the bow of this dragon boat. Bananas and incense are offered to Naga in hopes of ensuring a victory. C a m b o d i a.

with manicured fingernails danced wildly, as if in a trance. My head began to spin as these countless human dramas played themselves out all at once.

As evening came, I expected the riverside to quiet down, but instead the atmosphere became more and more frenzied. When I tried to take a shortcut through the front of the Royal Palace, I was surprised to find myself unable to move. Trapped in a flood of people, it was too late for me to retreat. I was bound to these sweaty bodies on my left, right, front, and back. As the man behind me tried to move forward, he pushed me, so I in turn was forced to push the back of someone in front of me.

Where did this intense energy come from? I didn't know that attending a festival would involve so much effort.... Struggling to leave, I realized that even if I attempted to move against the flow, I would have no idea which direction to take. In a situation like this, it is best to give oneself up to the will of the crowd.

The loud music blaring through every street-corner speaker, the angry voices and the laughter, assailing me from all directions, pierced my ears. The smell of grilled meat drifted by and merged with the odors of bodies and dust, stinging my nose. I began to feel sick.

What was I doing here? Why was I getting myself into these situations? Doubts I had felt several times during my journey began to cross my mind. I continued to travel down the Mekong because I was drawn by some unknown, powerful force, and I was here at this Water Festival for the same reason. Covered with sweat and dust, I was tired. But wasn't I actually enjoying this? Yes. I was happy just to be a part of the festival. Taking in the smell of this Asia encompassing both good and evil, the new and the old, the sacred and the profane, I felt keenly alive.

The fireworks were launched, lighting up the people standing in front of the Royal Palace. Everyone screamed in delight.

93
In the main event of the Phnom Penh Water Festival, long, thin boats carved in the shape of Naga race each other across the water.

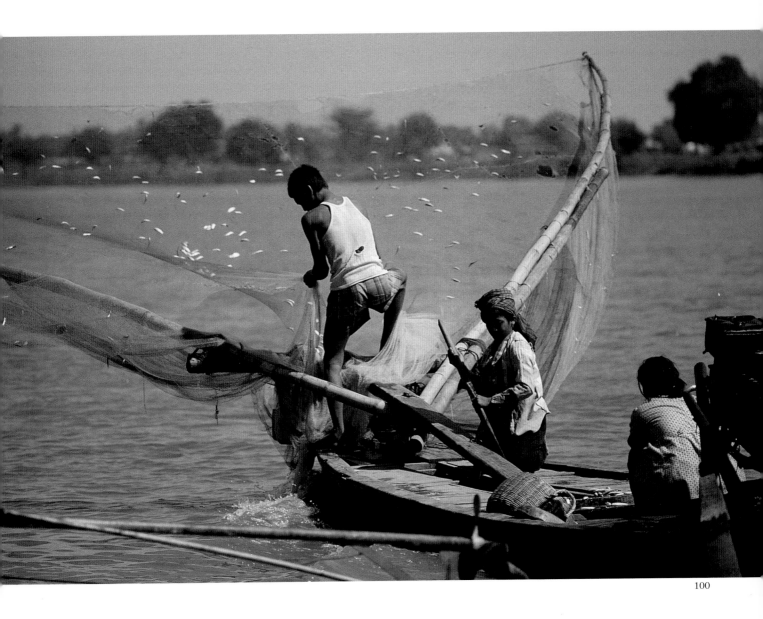

100

100
The Tonle Sap region is inhabited by Cham, Vietnamese, and Chinese, as well as Khmer. This family, fishing with large nets, is Vietnamese. C a m b o d i a.

101
In the morning, a merchant buys
fish at the Tonle Sap River. Dur-
ing the rainy season, the Mekong
flows backwards into the lake
called "Tonle Sap." During the
dry season, when the river flows
downstream again, fish become
more abundant. C a m b o d i a.

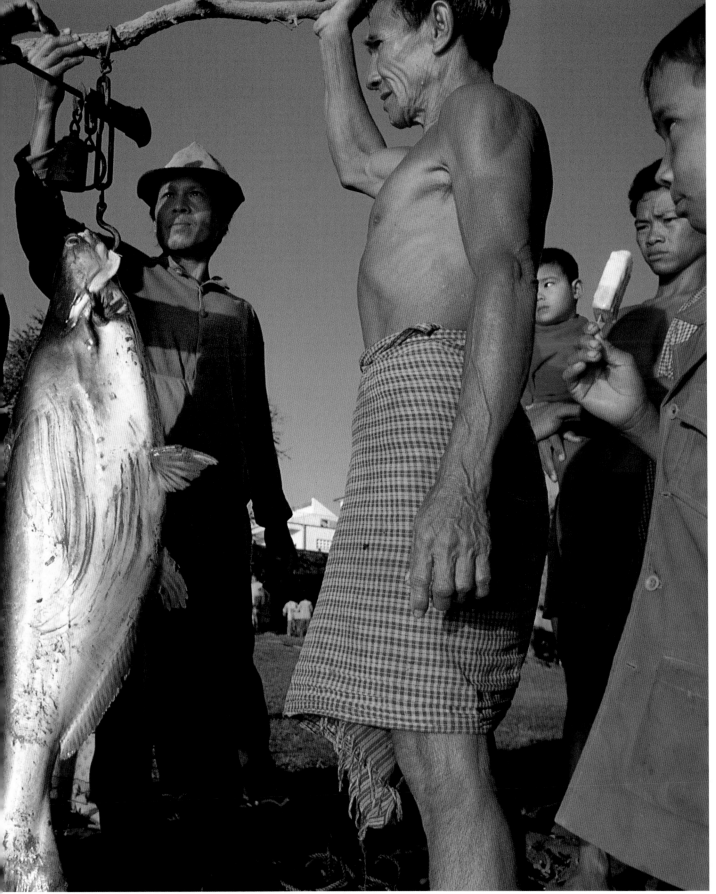

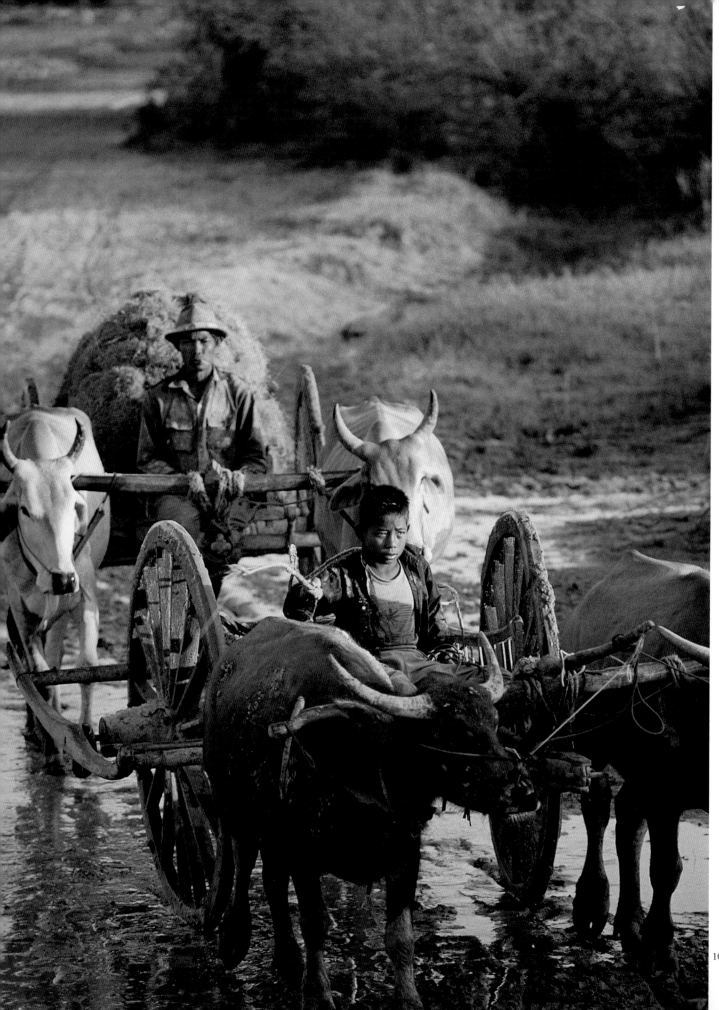

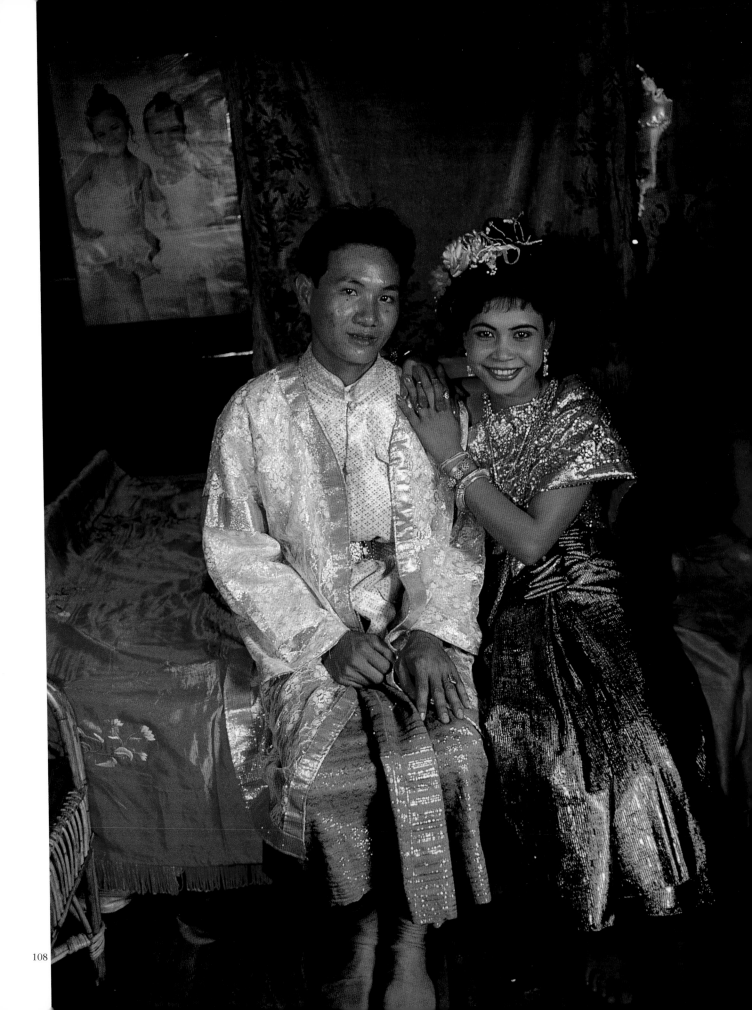

109
At the peak of the reign of the Khmer, Suryavarman II built the temple of Angkor Wat. These monks, who spent the night there, left before tourists arrived.

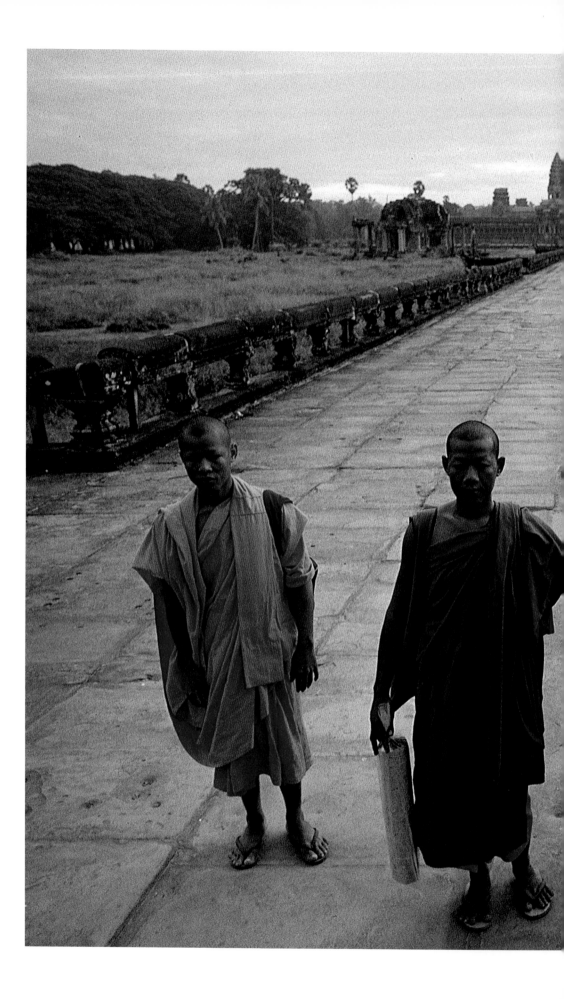

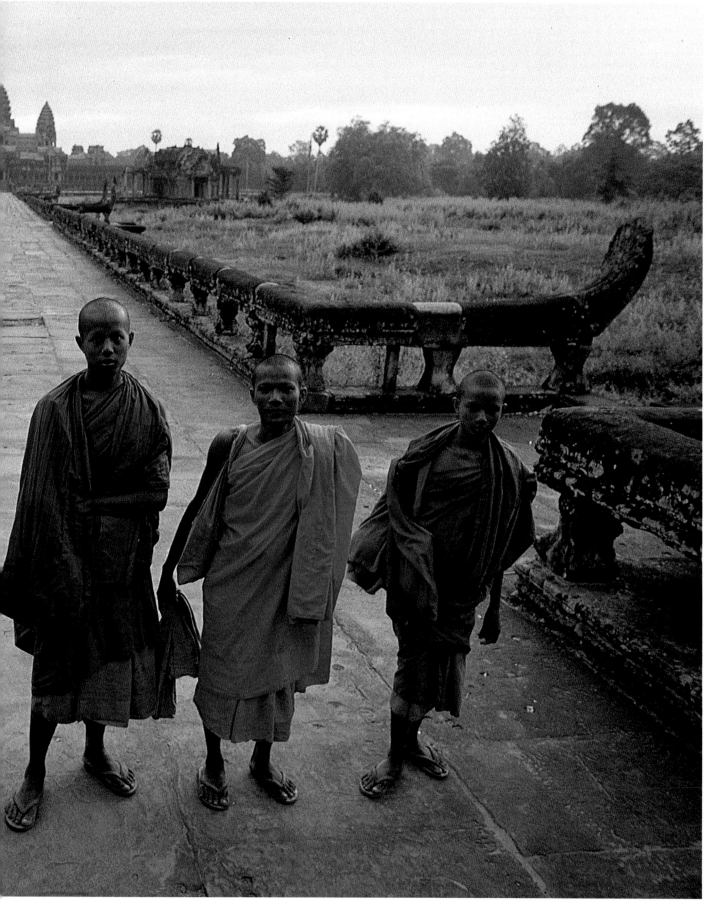

113

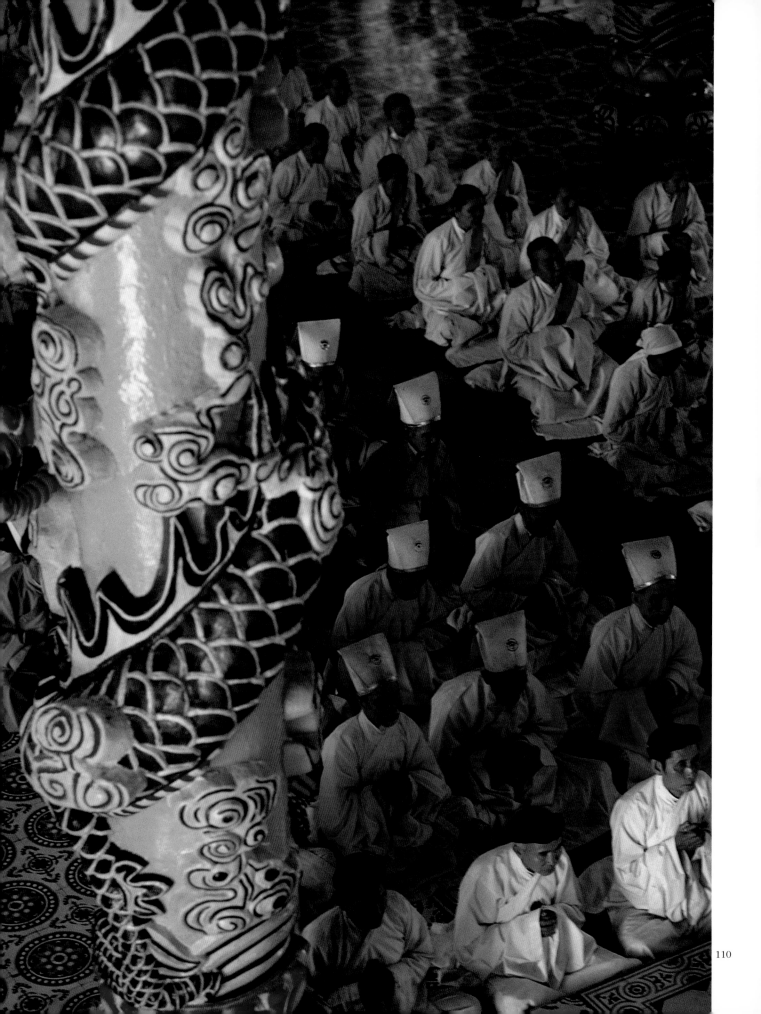

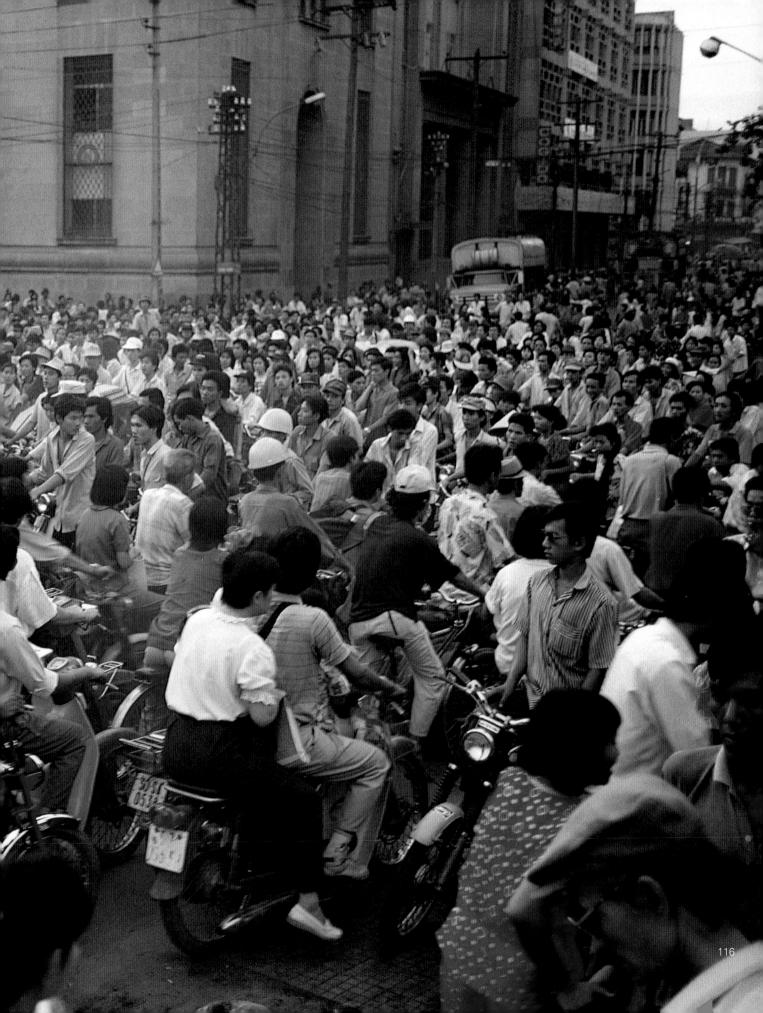

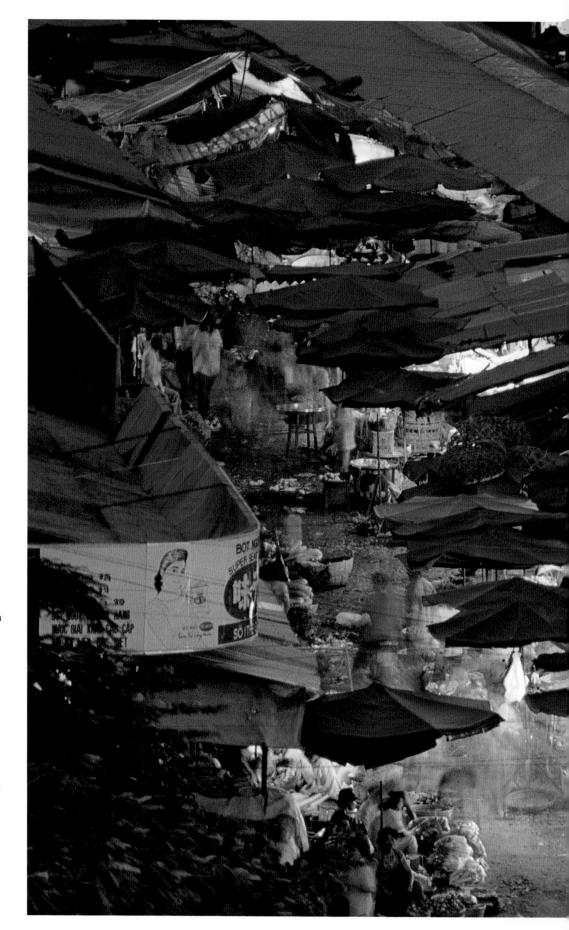

◀ 116
Doi moi has increased the pace
of life in Ho Chi Minh City, thus a
car accident in the middle of the
evening commute hour creates a
huge traffic jam. V i e t n a m.

117
In Vietnam the Mekong divides
into two large streams, the Tien
Giang and the Hau Giang. This
market is in Can Tho, the Mekong
Delta's largest city, built near the
Hau Giang. V i e t n a m.

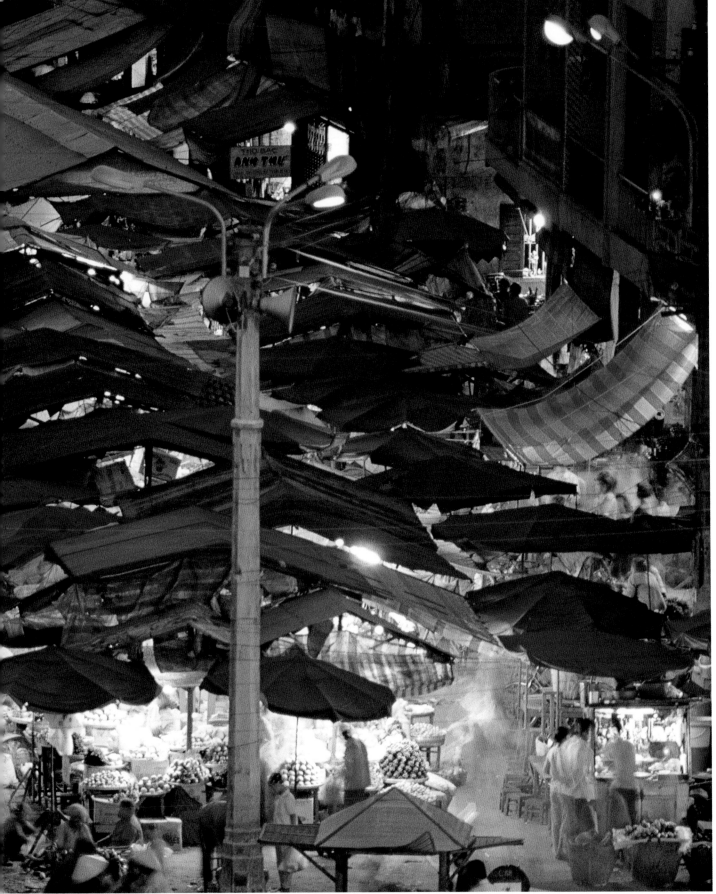

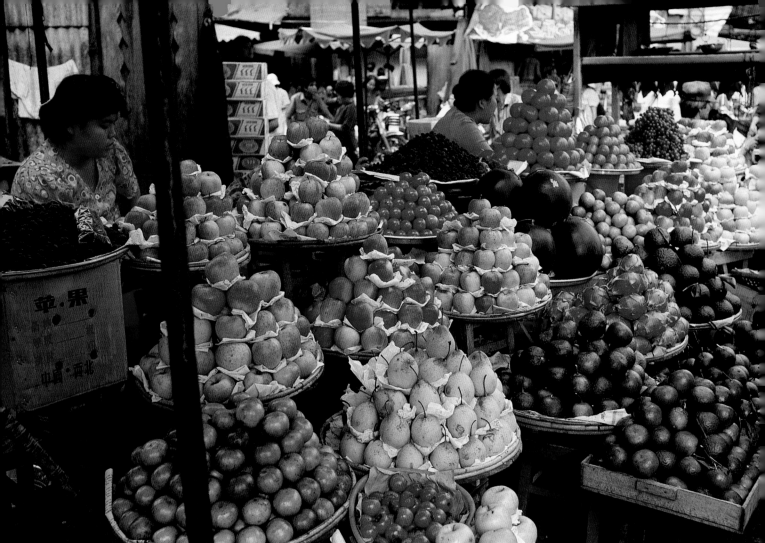

118
A variety of fruits are sold at the
Can Tho Market. Compared to the
simple meals at the source of the
river, this area is unbelievably rich
in produce. V i e t n a m.

119
At a rice store in the market of
Ho Chi Minh City, display cards
for goods list brand names and
points of origin as well as prices.

120
A woman sells bread at a bus
terminal. Because Vietnam, Cam-
bodia, and Laos were all former
colonies of France, baguettes are
popular there. V i e t n a m.

121
This man is trying to carry a live
duck on his motorcycle. In one
of the rural villages I saw some-
one stuff a banana into a duck to
increase its weight so it could be
sold for more money. V i e t n a m.

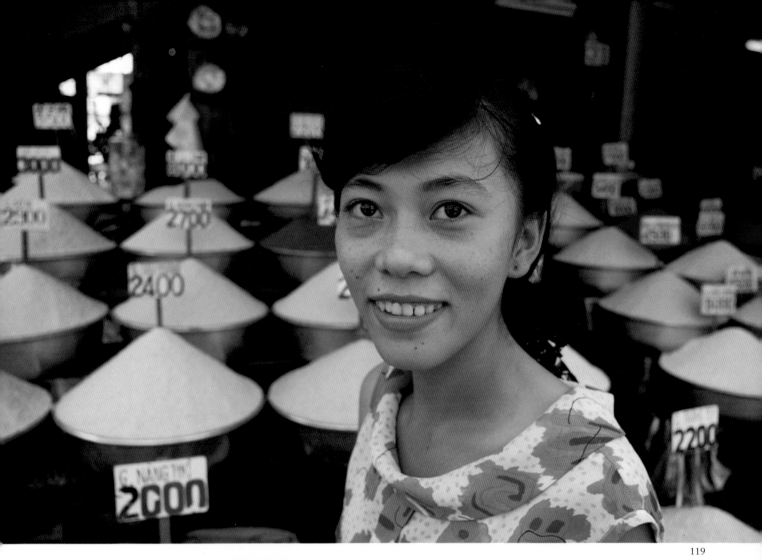

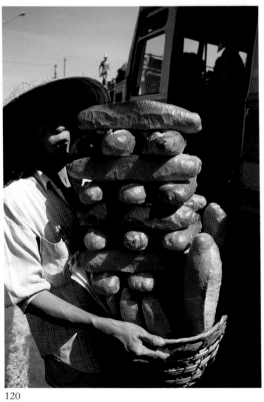

120

121

122

These paddy fields spread into the outskirts of Can Tho. The Mekong Delta is Vietnam's largest granary, producing so much rice that the country is able to export some of it. Rice products such as noodles and paper are manufactured here as well. V i e t n a m.

123

Women sell flowers at the entrance to the market at Tra Vinh. This sight made me realize that all the plants sold at the markets upstream were edible.

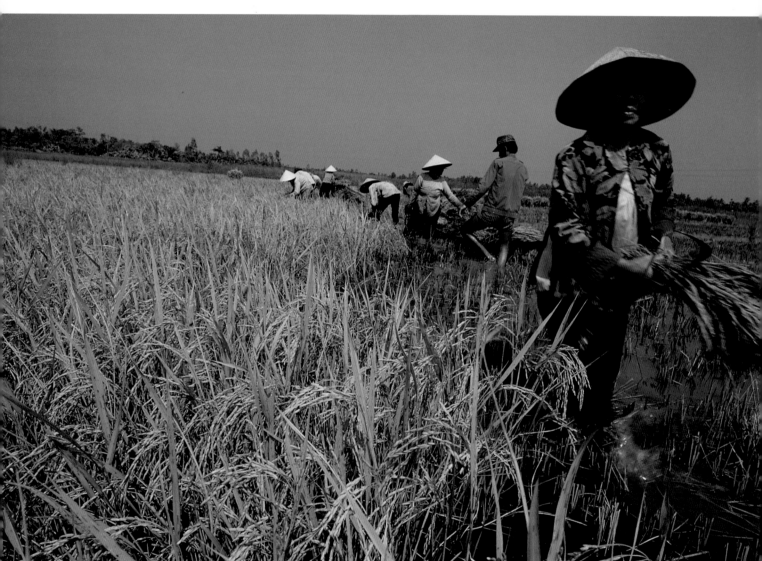

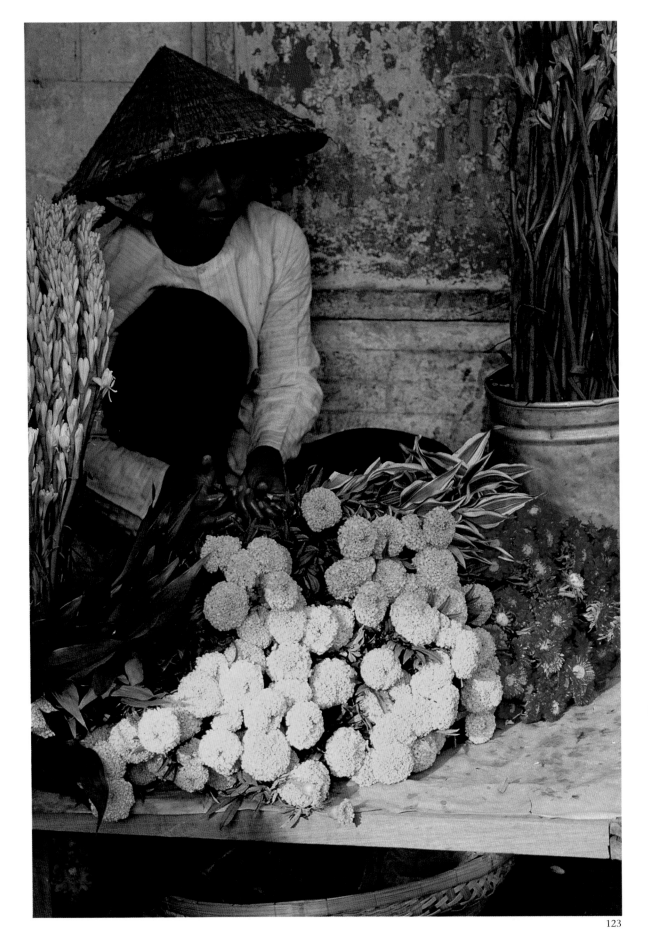

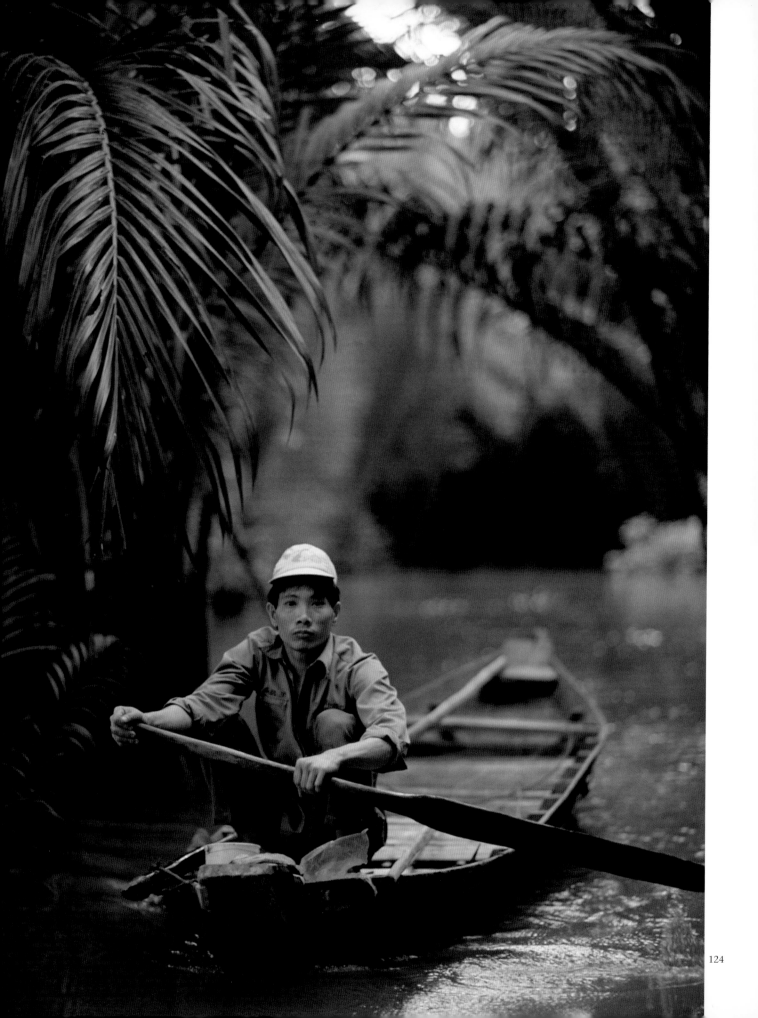

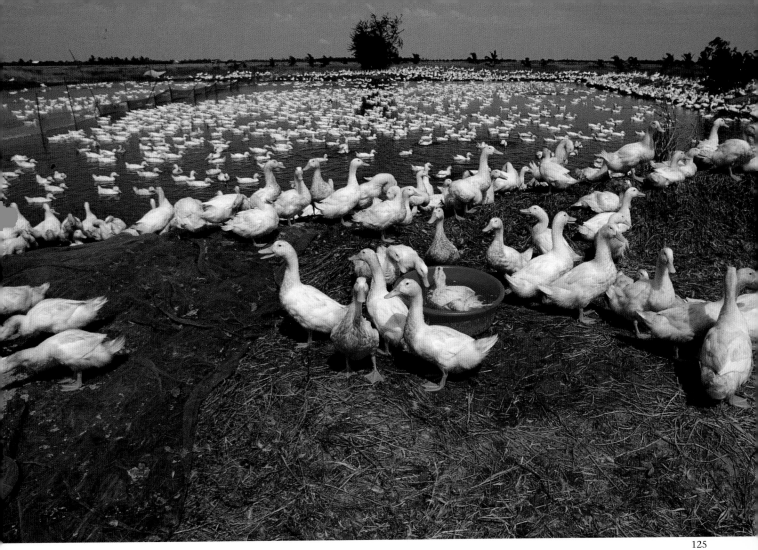

124
Near the sea, due to the tides, the water level of the Mekong Delta changes frequently, making travel by boat difficult in narrow canals. Local residents are always conscious of the tide when they travel by water. V i e t n a m.

125
At a duck farm on the outskirts of Ca Mau, a city in the southern region of the Mekong Delta, approximately 8,000 ducks are fed on the area's abundant rice. After three months here, they are shipped to Ho Chi Minh City.

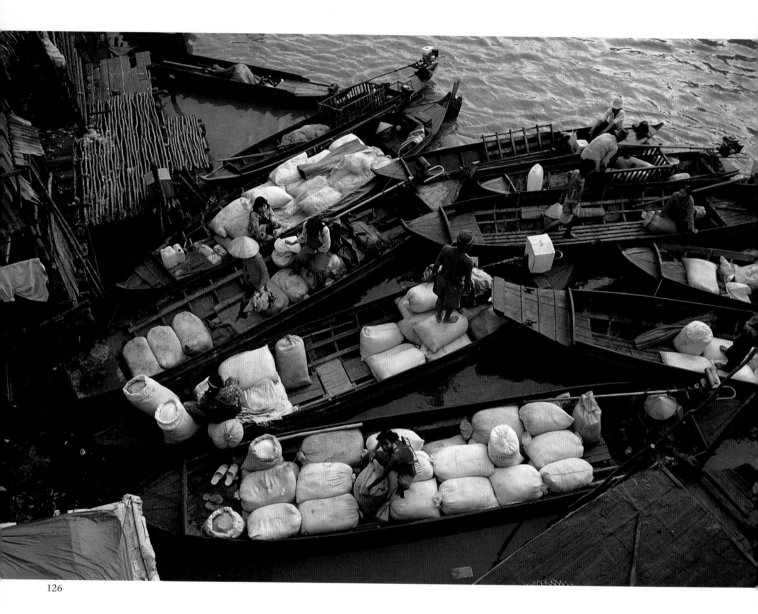

126
Transportation in the southern regions of the Mekong Delta is more sophisticated on water than on land. Goods brought from the outskirts are unloaded at the dock of the Ca Mau Market. V i e t n a m.

127
These small boats at a "floating market" in Can Tho are filled with vegetables and fruit. When a vendor approached me I bought a sandwich for an exorbitant price.

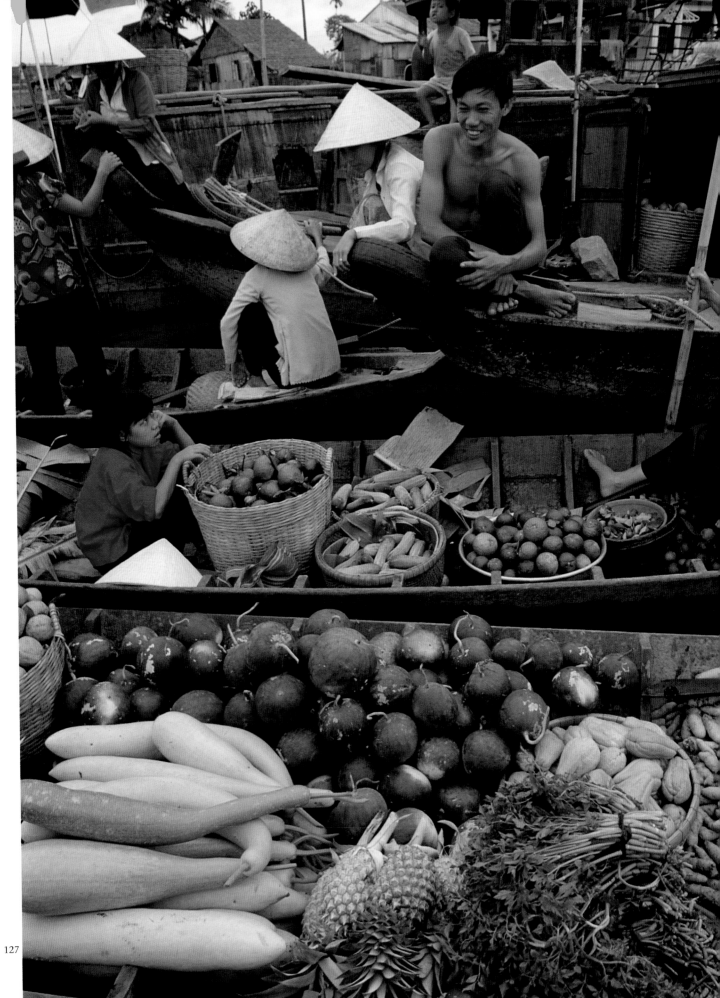

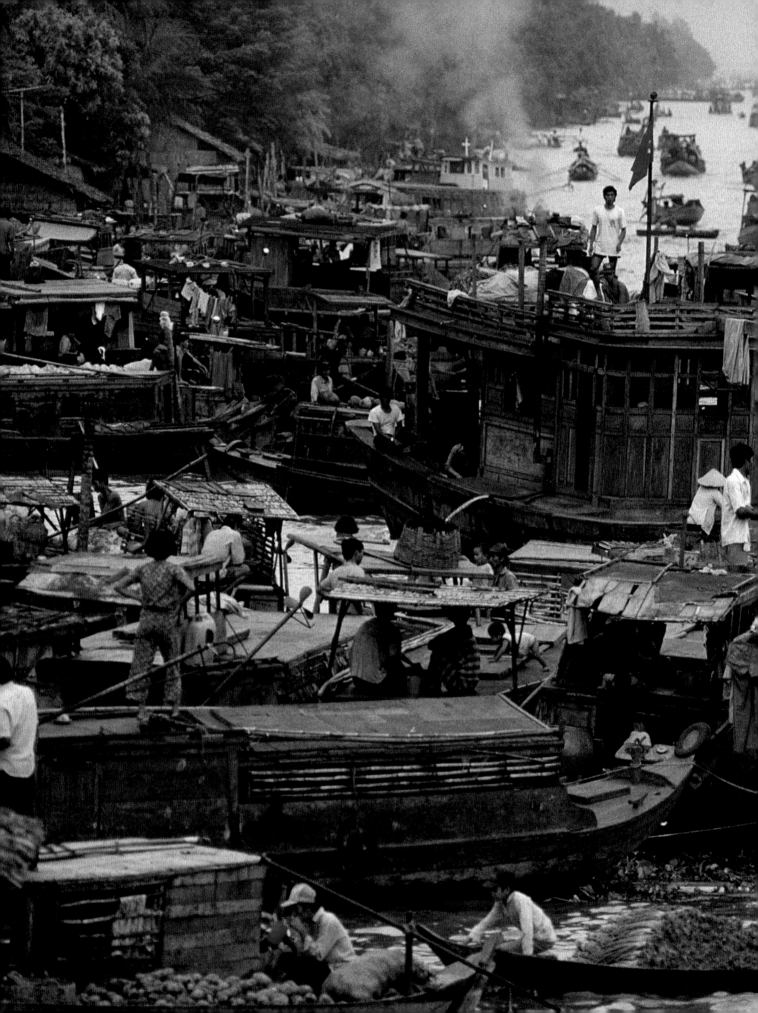

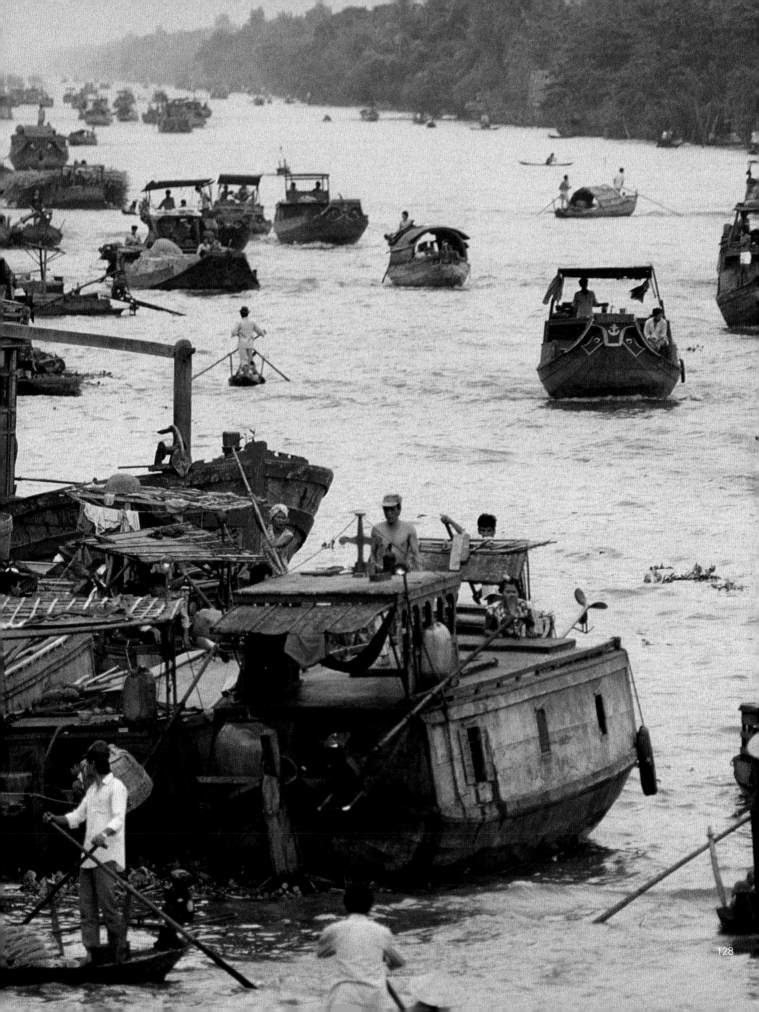

◀ 128

The floating market in Phung
Hiep, southeast of Can Tho and
forty miles from the South China
Sea, is crowded with boats both
large and small. The Mekong Delta
was rapidly developed in the latter
half of the nineteenth century,
when the French colonized the
area and dug a system of canals.
V i e t n a m.

129

129

Khmer were among the workers
unloading sand from this boat in
Tra Vinh. This area was occupied
by the Khmer until the Viet-
namese moved south. V i e t n a m.

130

Water buses provide transporta-
tion between various towns and
villages of the Mekong Delta. A
wave of the hand stops the boat
in rural areas where there are no
designated stops. V i e t n a m.

132

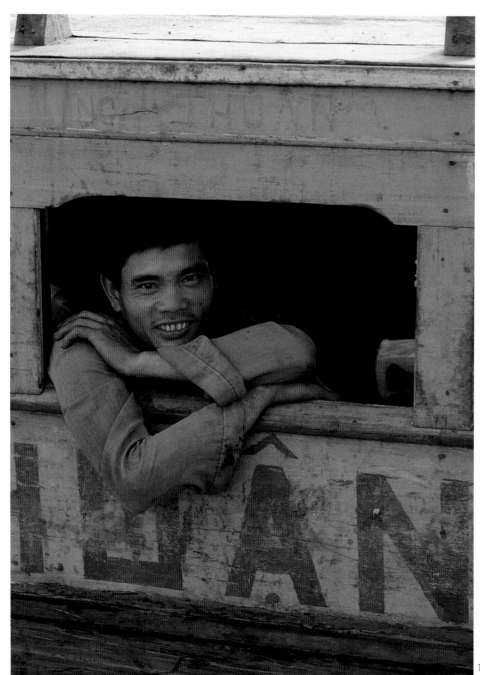

130

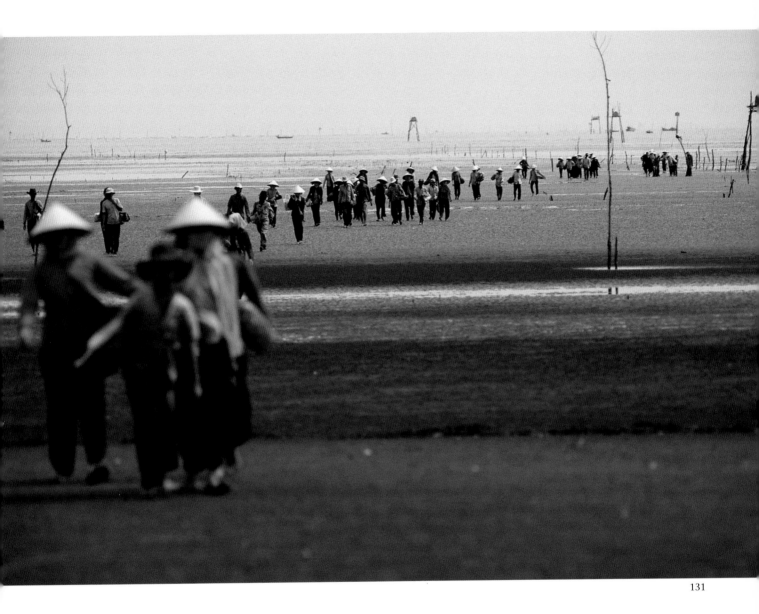

131
At the mouth of the river, a
shrimp farm has replaced some
mangrove forests. This shoal is
created by mud that has accumu-
lated in the river. As the tide goes
out, this area becomes a beach,
wider than a mile, where people
collect shells. The light-brown
area in the distance is the South
China Sea. V i e t n a m.

THE MEKONG DELTA—The Journey Ends

On the plaza of the Rex Hotel, newlyweds pose to have their wedding portraits taken. The statue of Ho Chi Minh serves as their backdrop. A group of friends surround the bride, who wears a pure-white wedding dress. The sight of these young people teasing the couple while taking pictures of them seems symbolic of the current peace and economic development in Vietnam.

The city is full of motorcycles, and buildings are covered with billboards advertising foreign corporations. Smothered by exhaust and noise, the statue of Ho Chi Minh looks as if it has shrunk in size. "Devoting yourself to Socialism, leading such a frugal life, Uncle Ho! How do you feel looking at these ads every day?" As the fastest developing area along the Mekong, Vietnam attracts worldwide attention. One can, however, leave behind the tumult of Ho Chi Minh City—where urbanites touting the battle cry *"Doi moi!"* (restructure) work incessantly to make money—and head towards the Mekong Delta, where the landscape transforms, and strong yet quiet farmers sink their roots into the land.

Taking a small boat from My Tho, I reach the mouth of the Mekong in just four hours. Surprisingly, the day is not windy, and the water is calm. I feel as though I am floating on an enormous pool.

132
The Mekong Delta divides into many streams; this is the mouth of the Tien Giang, viewed from the ocean. V i e t n a m.

Staring down at the water, I see the mud swirl gently like the surface of hot miso soup. In Vietnam, the Mekong is named "Song Cuu Long," or "River of the Nine-Headed Dragon." Dividing into many smaller rivers that wind through the delta's rice paddies like the writhing necks of an enormous dragon, the Mekong finally descends into the sea.

Occasionally, the sound of engines can be heard in the distance, signaling the return of a large fishing boat from foreign seas. I have been preparing myself for harsh open ocean, so I am slightly disappointed by its placidity. Nonetheless, the heat is intense, and as I fondly recall the cold weather at the source of the river, I stretch out my hand from the dock and dip it into the water, just to make sure it tastes of salt. I think to myself, I've completed my journey from the headwaters of the Mekong River to its mouth! and realize that my odyssey has come to an end.

On the horizon, the pale-blue sea and sky melt together until no line of distinction can be drawn between them. Perhaps the evaporating water will drift toward the source of the Mekong, eventually falling upon the holy mountain as rain or snow. In the distance, without my noticing it, a towering mass of clouds has reared up over the ocean. It looks like a dragon, sent by the god of the sea.

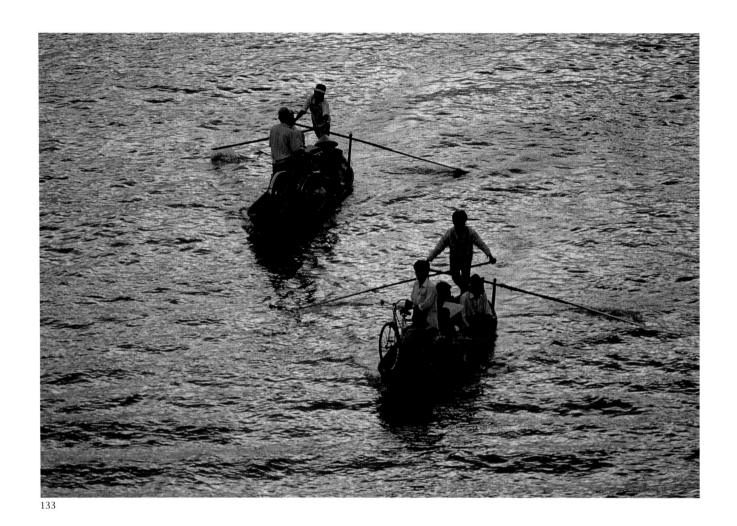

133

133
Boats are vital in the Mekong
Delta, 2,500 miles from the
Mekong's source high in the
Tibetan Highlands. This vessel
ferries people across the brim-
ming river. V i e t n a m.

Where does it come from?
Where does it go?

The river of people flows on....

Photographing the Mekong for the First and Last Time

By Hitoshi Takase

The source of the Mekong River has remained a mystery for a very long time. This book finally illuminates that mystery. It is an admirable feat. I've known far too many people who have made similar attempts to trace the path of the river, only to abandon their efforts due to the harsh traveling conditions in the mountains and the difficulties of doing journalistic work deep in China. Consequently, we have been waiting a long time for these photographs of the source. And—I must say—these majestic photographs are truly breathtaking.

On April 11, 1995, a joint research team from France and England officially announced that they had discovered the source of the Mekong in Qinghai Province, China. It was reported to be a watershed between the Yangtze River and the Mekong, located on the peak of the Rup-sa Pass, at an altitude of 16,300 feet. This was an incredible discovery.

However, the Mekong we had been waiting to discover could never be elucidated through science. What we had been waiting to see was the whole of the Mekong's landscape, the daily interactions between the river and its people. What makes Aoyagi's photographs of the Mekong's source so significant is that they finally depict the river as it is *experienced* on a daily basis.

The Mekong offers a wide range of sights. Beginning in the snow-covered Tibetan Highlands, the source grows into the turbulent river that runs through Yunnan Province. After passing Vientiane, the fully mature Mekong flows smoothly between the borders of Thailand and Laos. Gaining strength at the Phapheng Waterfall, it enters Cambodia, where it becomes the "River of Fertility." During the rainy season, the Mekong floods the vast plains of Cambodia, nurturing abundant crops. It then splits into nine streams, gracefully ending its journey at the Mekong Delta, Asia's granary, where crops can be raised three times in one year.

The deep wrinkles carved in the faces of old Tibetans testify to the harshness of life near the source of the Mekong. The warm, carefree smile of a Cambodian girl... The hardworking, shrewd merchants of the Mekong Delta... This book not only shows us the incredible diversity of the inhabitants of the Mekong region, but also manages to reveal the intense dramas that take place along the river's shores.

Many major rivers can be traced back to the Tibetan Highlands: the Yellow River, the Yangtze River, the Ganges, the Indus, and the Salween. The Mekong is exceptional among this group for its internationalism; in all, it runs through six countries. Furthermore, the Mekong supports a greater diversity of tribes and cultures than these other rivers. In this sense, the Mekong could be called the "River of Tribes."

The region from Yunnan through the northern parts of Myanmar, Laos, and Thailand is especially rich in diversity. In terms of linguistic genealogy, dozens of local tribes speak languages ranging from Thai to Tibeto-Burman to Mon-Khmer, producing a rich mixture of dialects. The string of valleys carved out by the Mekong serve as transportation routes for all these tribes.

Near the Chinese border in northern Laos live the Thai Lu people, who speak a Thai language. According to them, the land of their ancestors is located in Xishuangbanna, Yunnan. Many of their relatives can still be found there. The Thai Lu are very skilled at making handwoven silk goods. The Thai Lu tribespeople I met pointed to the zigzag pattern of a fabric and told me it was "the pattern of the river." Looking at it, I felt I could see the history of their descent down the Mekong pass before my eyes.

Aoyagi saw the Mekong for the first time at the dragon-boat races in Yunnan Province (photo 3). These boat races, which take place in various

regions along the river, give the Mekong a poetic charm during the dry season. Photographs 92 through 96 depict the dragon-boat races at Phnom Penh. Below Yunnan, the dragon boats of Laos, Thailand, and Cambodia all display images of Naga, a multiheaded snake deity which originated in India. Dragons and Naga both serve as water gods, inducing rich harvests by providing water.

In Louangphrabang, Laos, and Nong Khai, Thailand, I had the opportunity to watch boat races on the Mekong. Villages compete against each other. To prepare for the races, the villagers touch up their Naga boats, which have been stored inside temples, and present the boats with offerings. On the day of the races, entire villages empty; everyone from well-dressed young women to stooping old men go to cheer on their village's team, urging the boats on by beating cymbals and drums. The people here are usually reserved, but on this day some of them even jump into the river out of excitement. Their enthusiasm for the boat races reveals how powerful a presence the Mekong is to them.

Ceremonies honoring Naga can be seen everywhere along the Mekong. During the dry season in the northeastern region of Thailand, the Rocket Festival takes place. Bamboo rockets loaded with gunpowder shoot up into the air and land in rice paddies. The bamboo rockets symbolize men, and the paddies women. By celebrating this metaphor for procreation, the villagers pray for good crops. As a symbolic gesture, these rockets also are decorated with images of the snake god.

The Mekong River flows with the spirit of Naga until it finally splits into a "nine-headed dragon" before entering the South China Sea. The legend that claims the dragon as the guardian of the source of the Mekong seems entirely appropriate. It is, after all, a holy river.

The beginning of this book depicts a serene stretch of the Mekong at Vientiane, the small capital of Laos. The sun is setting behind the red-tinged river. The Mekong at twilight in Vientiane is truly one of the most beautiful sights offered by the river.

In January of 1983, I stayed in Vientiane in a hotel beside the Mekong. It was the dry season. Although during the rainy season the river grows wider than a half mile, during the dry season its width shrinks to barely 300 feet. That night, gunfire was exchanged between Laos and Thailand, and the following morning there were numerous holes in the hotel walls from the bullets shot by Thai soldiers. In those days, during the dry season, countless Laotian refugees attempted to swim

across the Mekong to Thailand. Needless to say, border tensions were extremely high.

Until recently, the Mekong was often referred to as the "River of War." Following the First Indochina War, the antagonism between countries in the Mekong region—a focal point of the Cold War—only escalated. Wars were fought between Thailand and Laos, Vietnam and Cambodia, China and Vietnam, and China and Laos. The bloody struggles within each nation were no less horrific. Both Laos and Cambodia suffered long civil wars, Thailand waged war against Communist guerrillas, and Myanmar experienced drug wars involving the CIA. The Mekong has witnessed countless deaths along its path, and the legacies of these wars continue to take their toll in all the countries through which the river flows.

During the Vietnam War, the U.S. military dropped vast quantities of defoliants onto the Mekong Delta to destroy jungles that sheltered elusive enemy guerrillas. Unfortunately, plants were not the only living things affected by this dioxin. The chemicals caused genetic mutations in people; as a result, cancer, leukemia, pregnancy complications, miscarriages, and the birth of deformed children rapidly became more prevalent. No extensive research has been undertaken on the impact of the dioxin, and deformed children liv-

ing in these areas continue to suffer from hydrocephalus and other birth defects. Many have been born without fingers, eyes, or limbs.

In addition, countless farmers have been killed when they accidentally struck an unexploded shell with their hoes, and many children have lost their legs when they stepped on a mine buried during a civil war. Such tragedies continue to occur even today.

Carrying the legacy of its tragic past, the Mekong is entering a new age. Since 1994, Yunnan and northern Thailand have been linked by a liner that runs regularly between them, passing through Laos and Myanmar on the way. Around the midpoint of the Mekong, near Vientiane, the first bridge to cross the river from Laos to Thailand has been constructed. Its name is the "Bridge of Friendship."

The "River of War" has become the "River of Friendship," a place where people live in peace and travel freely. However, at the same time, a wave of international development has descended upon the river. As the Cold War comes to a close, the "Age of Economics" has finally arrived, sweeping through Southeast Asia's last virgin territory, the Mekong region.

This international development plan, led by the Asia Development Bank, entails constructing

141

numerous dams along the Mekong's tributaries, and building bridges, roads, and ports along the main waterway. Each country's private sector has begun various projects, including the development of resorts and mines.

Even basic changes, such as the relaxing of border tensions and the improvement of river transportation, have drastically affected the lifestyles of those who live by the Mekong. For example, the mountain tribes' age-old traditions of weaving their own fabrics by hand have quickly been left behind; tribespeople now purchase cheap synthetic textiles from abroad, and discarded weaving machines are collecting dust. Dealers in antiques have entered the previously isolated inner regions of both Myanmar and Laos, and are buying up everything from ceremonial equipment and faith healers' costumes to musical instruments traditionally used for funerals.

A rare species of river dolphin lives near the Phapheng Waterfall. Only 100 of the animals are said to remain, and when the plans to construct dams go into effect, these dolphins will be separated from each other, and will probably become extinct.

Whether one likes it or not, the ecosystem of the Mekong, as well as the variety of cultures that live along the river, will inevitably be changing

rapidly in the immediate future.

This is the first book of photographs to depict the entire Mekong River, from its source to its mouth. The project became possible because of the sudden, unprecedented opportunity to travel freely through this region. But this book may also be the last of its kind. No doubt, many of the scenes found here will disappear in the very near future.

We already feel nostalgic as we view these images of the Mekong for the first time. It is a sign of our times.

Hitoshi Takase was born in 1953 in Japan. A television journalist by profession, he specializes in Southeast Asian affairs. He was stationed as a correspondent in both Thailand and the Philippines. Takase has visited all six countries through which the Mekong River passes.